book is to be returned on or before
the last date stamped below.

Calder

Great Modern Masters

Calder

By Gérard-Georges Lemaire

Translated from the French by Sophie Hawkes

CAMEO/ABRAMS

HARRY N. ABRAMS, INC., PUBLISHERS

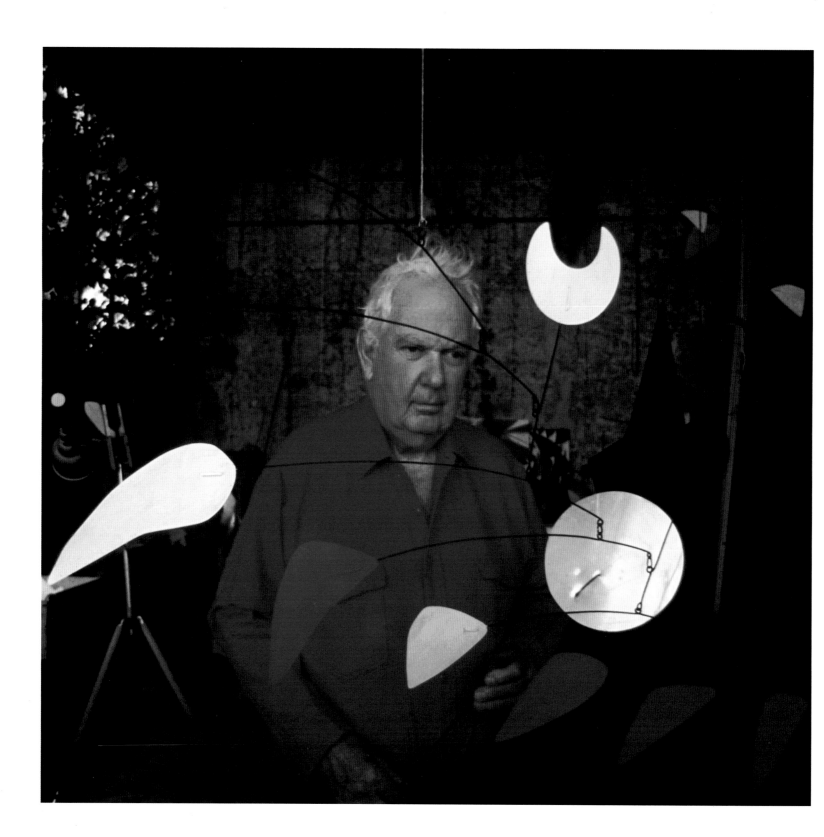

Calder's Work in the Twentieth Century

The Cirque Calder as Representation of the Plastic World

After arriving in Paris in the summer of 1926, Alexander Calder devoted himself wholeheartedly to a project that would occupy him for over five years: the elaboration of a miniature circus called the *Cirque Calder*. This microcosm of games contains characters and animals made out of wire, scraps of cloth, wood, cork, labels, bits of

scrap metal and pieces of rubber. Calder transported his little theater of the world in suitcases and performed it for his friends. He set up his tent and arranged the performers—the man on stilts, the horsewoman on her mount, the lion, the dog, the seals—while his friend Isamu Noguchi turned the crank of a phonograph. During his performances, Calder invented ways to simulate the flight of birds: "These are little bits of white paper, with a hole and slight weight on each one, which flutter down several variously coiled thin steel wires which I jiggle so that they flutter down like doves . . ." (Alexander Calder, *An Autobiography with Pictures* [New York: Pantheon, 1966], p. 92). The *Cirque Calder* made a great impression on artists and literati alike, including Joan Miró and the American writer Thomas Wolfe who described it caustically in his novel *You Can't Go Home Again*.

The *Cirque Calder* is, in fact, the laboratory of Calder's work; in it he experimented with new formulas and techniques. During this same period he developed wire figures such as *Josephine Baker*, *The Negress*, and the *Portrait of Edgar Varèse*, while continuing to draw and to create circus scenes. Next he worked in wood, creating *The Horse*, *The Cow*, female nudes, and *Old Bull*, between 1928 and 1930, eventually becoming interested in the movement of objects, some with motors. He exhibited such objects in his early one-man shows in Paris at the Percier Gallery in 1931, and at the Vignon Gallery in 1932. Calder's association with Fernand Léger and Piet Mondrian was decisive, and under their combined influence, Calder discovered what he wanted: "to paint and work in the abstract" (Calder, p. 133). He created relief paintings such as *White Panel* (1934) and applied himself thereafter to creating sculptures based on the plastic dynamics of asymmetry.

Two Sides of One Question: Mobiles and Stabiles

Calder searched for the paradigmatic space within which to display his ideas; the celestial vault and the Milky Way provided the inspiration he needed to construct a universe at once abstract yet bound to tangible reality. In 1933, Calder acquired a studio in Roxbury, Connecticut, where he completed *Object with Red Discs*, commonly known as *Calderberry Bush*, a sculpture he described as a "two-meter rod with one heavy sphere, suspended from the apex of a wire. This gives quite a cantilever effect. Five thin aluminum discs project at right angles from five wires, held in position by a wooden sphere counterweight" (Calder, p. 149). Thus was born the idea of the mobile, a manifestation of the dream of the Italian futurist Umberto Boccioni: the moving statue. The concept of the suspended mobile, subject to the aleatory movements caused by the interaction of weights and counterweights, was developed in 1934. By 1939, *Rusty Bottle* proved that Calder was capable of exploring all the consequences of his plastic investigations. The animal kingdom inspired him in this endeavor, with *Steel Fish* (1934), *Praying Mantis* (1936), and *Spider* (1939), as evidence of this vital evolution.

As odd and paradoxical as it may seem, Calder's fascination with time and the play of volumes in space reinforced his desire to anchor static figures in the ground, to give a sense of immutability. His compositions were initially fragile structures and for months he struggled with problems of construction. In 1937, he successfully conjoined steel planar forms and designed *Whale*, the prototype of the stabiles he created after World War II. Calder was also preoccupied with sculpture that embodies architectural metaphor, largely derived from the forms of medieval cathedrals. His *Gothic Construction from Scraps* is a monument in flying buttresses and lofty naves, establishing the constructive principles of his future stabiles.

The artist's progress was slow and often circuitous. In creating his *Constellations* in 1943, Calder explored the plastic possibilities of mobiles; he used small pieces of wood (replacing aluminum), which he shaped and sometimes painted, and "between which a definite relation was established and maintained by fixing them on the ends of steel wires" (Calder, p. 149). Such was the birth of the synthesis of mobiles and stabiles, sculptures placed on the ground or on a table.

Once World War II was over, Calder freely created objects that maintain a rare balance between a playful spirit and a desire to defy time, Calder's great preoccupation.

Opposite:
Calder with one of his mobiles, August 1967. Photo: AKG Paris/Tony Vaccaro

Circus drawing

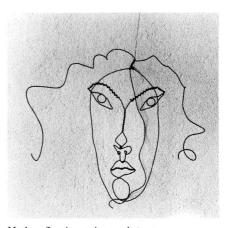

Medusa/Louisa, *wire sculpture*

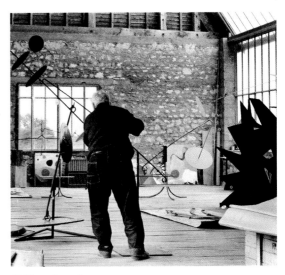

Calder at work

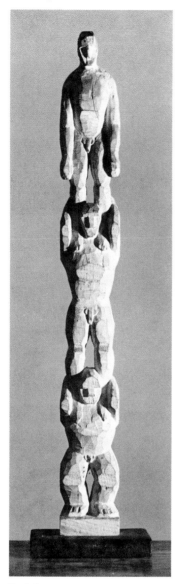

Trois hommes en hauteur,
wood sculpture

From this point on, Calder's ambition changed direction. He wanted to cover the world with his numerous creations that challenged monumentality itself. But Calder refined his explorations as he put to use the formal repertoire he had perfected during the preceding decade. His stabiles were part of the neo-functionalist aesthetic of that time; such works as *Object in Five Planes/Peace* (1965), in front of the U.N. headquarters in New York, or *The Red Spider* (1976), on the esplanade of la Défense, Paris, also created an ideal counterpoint to this aesthetic.

His mobiles took up the challenge as well, responding to two complementary objectives. The first consisted of displaying objects in the air, giving the viewer the experience of finding new skies filled with moving and colored constellations. Calder accomplished this in *Acoustic Ceiling* (1954), or in the mobile, *.125*, at Idlewild (now Kennedy) Airport, New York. The second objective was to combine the two complementary principles of his sculptural work. The *Crinkly with Red Disc* (1973) and *Carmen* (1974) for the Museo Nacional de Arte Moderna de Madrid, are the most striking examples.

Calder, who eschewed all dogmatism, made representational sculptures demonstrating an ability to render tangible his graphic sense and humor. *Le Bougnat* (1959), *The Pagoda* (1963), *Le chien en trois couleurs* (1973), *Black Flag* (1974), the Critters series, and *Le soleil sur la montagne* (1975) all demonstrate a desire to transform their enormous volumes into images with Calder's humor winning out over more austere formal considerations. Calder also cut fantastic animals from sheet metal, creating *La vache* and *Elephant* (both 1970) and a mobile entitled *Nervous Wreck* (1976), which represents the red skeleton of a fish.

Calder's Universe and Discoveries

After studying engineering, Calder learned to draw and paint in New York and Paris. To make ends meet, Calder drew caricatures and illustrations for various periodicals and designed toys. These seemingly disparate experiences enhanced Calder's personal artistic research. Calder expanded his investigations, eventually defining his own type of work: in 1926 he published *Animal Sketching*, a textbook to teach drawing to beginners; he explored wood sculpture, creating, among others objects, *The Horse* (1928); and he made bronze castings, such as *The Cat* (1930). His wire sculptures, such as the four *Josephine Bakers*, the heads *Edgar Varèse* and *Fernand Léger*, *Acrobats*, and *Brass Family*, belonged to a new generation of works that made up the foundation of his early one-man shows.

These shows did not, however, contain only one kind of piece. He exhibited abstract constructions as well that revealed a considerable qualitative leap. From the start, he had sought out the company of the radical Abstraction-Création group. As he said in his autobiography, he associated with "[Jean] Arp, Mondrian, Robert Delaunay, Pevsner, and Jean Hélion, among about thirty in all" (Calder, p. 114). Much has been made of Piet Mondrian's influence in particular. Calder certainly was much impressed by his visit to the artist's studio; he even wrote that it was the "shock that started things" (Calder, p. 113). Calder's sculptures of the period prove that he had observed and learned not only from Mondrian, but from such artists as Pablo Gargallo; Julio Gonzalez; László Moholy-Nagy, who introduced the movement and dynamism of the Italian Futurists; Roman Clemens, a student at the Bauhaus who championed wire; Naum Gabo; and Antoine Pevsner. Linear sculptures such as *Little Ball with Counterweight* (1931), *Cruise/Universe* (1931), and *Spheriqué I/The Pistil* (1930) extended his creation of wire portraits. Calder also expanded his repertoire producing relief paintings such as *The White Frame* (1934) and *Day and Night* (c. 1937), in which he was intrigued by objects that function symbolically, and by the Surrealists; their contribution is also evident in *The Cock* (c. 1942).

During World War II, Calder reached his artistic maturity, creating works that made him famous throughout the world. These objects had great impact on the history of sculpture, for in them Calder proved himself capable of synthesizing and sublimating the theories of the avant-garde artists of the beginning of the century.

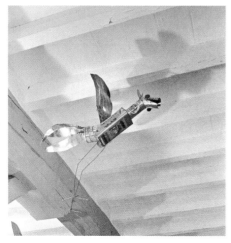

Tin bird

Biographical Outline

August 22, 1898 Birth of Alexander (Sandy) in Lawnton, Pennsylvania (near Philadelphia), to the sculptor Alexander Stirling Calder and Nanette Lederer.

1915 Admitted to the Stevens Institute of Technology, Hoboken, New Jersey.

1919 Receives degree in engineering.

1922 Travels to New York. Takes drawing classes from Clinton Balmer. Stoker on a freighter bound for San Francisco. Finds work in a logging operation on the West Coast.

1923 Enrolls in the Art Students League, New York. Takes courses from, among others, Thomas Hart Benton.

1924 Works for the *National Police Gazette*.

1925 Makes drawings for the Barnum & Bailey Circus. Decorates a sporting goods store, A. G. Spalding, on Fifth Avenue, New York.

1926 First exhibition of paintings at The Artist's Gallery in New York. Publishes *Animal Sketching*, a drawing textbook. Joins the crew of a British merchant ship as a sailor. After a brief stay in England, goes to Paris to take drawing classes at the Académie de la Grande Chaumière. Travels to New York in the autumn with the money he earns from drawings for an advertising brochure. Takes a studio in the rue Daguerre in Paris. Participates in the Salon des Indépendants.

1927 First performances of the *Cirque Calder*. Shows moving objects at the Salon des Humoristes. Returns to New York and produces "moving toys" in Oshkosh, Wisconsin, for the Gould Manufacturing Co.

1928 Performs the *Cirque Calder* in his home in New York.
February: One-man show at the Weyhe Gallery, New York.
March: Shows two sculptures at the New York Society of Independent Artists.
Summer: Makes wood sculptures at a farm in upstate New York.
Autumn: Returns to Paris and again performs the *Cirque Calder*. Participates in the Salon de l'Araignée. Meets Joan Miró.

1929 January: One-man show at the Billet Gallery, Paris. Pascin writes the introduction for the catalogue.
February: Participates in a show of wood sculpture at the Weyhe Gallery, New York. Shows in the Salon des Indépendants, Paris.
April: Show at Neumann und Nierendorf Gallery, Berlin (wire jewelry and sculptures); performs the *Cirque Calder* there.
June: Returns to New York and resumes performances of the *Cirque Calder*.
October: Participates in a group show at the Harvard Society for Contemporary Art in Cambridge, Massachusetts.
December: Shows works at the 56th Street Gallery, New York. Creates his first *mobile*.

1930 January: Participates in a show at the Harvard Society for Contemporary Art, Cambridge, Massachusetts.
March: Visits Barcelona and returns to Paris.
Spring: Travels in the south of France and Corsica.
Autumn: Meets Fernand Léger and Theo Van Doesburg. Visits Piet Mondrian's studio. Shows at the Salon des Surindépendants and at the Salon de l'Araignée.
December: Participates in a show at the Museum of Modern Art, New York.

January 17, 1931 Marries Louisa Cushing James in Concord, Massachusetts.
April: Shows at the Percier Gallery, Paris; catalogue introduction by Fernand Léger. Participates in a show of the Abstraction-Création group at the Porte de Versailles, Paris. Illustrates Aesop's *Fables*.
Summer: Stays in Majorca and Brittany.

1932 February: Presents motorized sculptures, called *mobiles*, at the Vignon Gallery, Paris. Takes part in the show "1940," Paris.
May: Show at the Julien Levy Gallery, New York.
September: Trip to Barcelona.

1933 Spring: Group show at the Pierre Gallery, Paris, with Arp, Miró, Pevsner, Hélion and Séligmann.
May: One-man show at the Pierre Colle Gallery, Paris.
June: Shows at the University of Madrid, and at the "Friends of New Art" in Barcelona.
August: Shows at the Berkshire Museum, Pittsfield, Massachusetts. Buys Roxbury Farm in Connecticut.

1934 April: One-man show at the Pierre Matisse Gallery, New York.

1935 February: Participates in the show "Thesis, Antithesis, Synthesis" at the Kunstmuseum, Lucerne.
April 20: Birth of Sandra Calder
Summer: Designs the sets for *Panorama*, a ballet by Martha Graham. Publishes a portfolio of etchings, *23 Gravures* (23 Etchings).

1936 February: Creates plastic interludes for *Horizons*, a ballet by Martha Graham. Designs sets for *Socrate* (Socrates) by Erik Satie at the Hartford Music Festival, Connecticut. Shows at the Pierre Matisse Gallery, New York.
April: Participates in the show "Modern Painters and Sculptors as Illustrators" at the Museum of Modern Art, New York.
December: Participates in the show "Fantastic Art, Dada, Surrealism" at the Museum of Modern Art, New York.

1937 Invited by Josep Lluis Sert and Louis Lacasa to create a fountain for the Spanish Pavilion at the

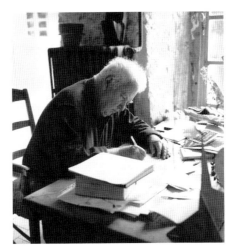

Portrait of Calder at work

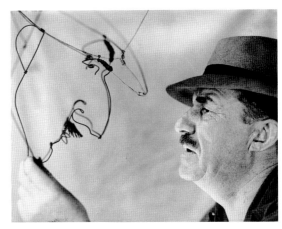

Portrait of Fernand Léger

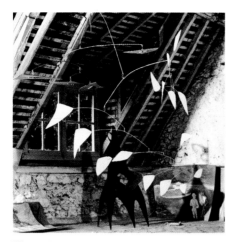

View of the studio at Saché

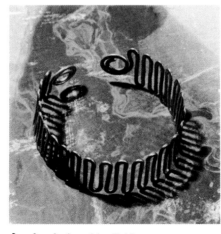

Jewelry designed by Calder

World's Fair in Paris.
June: "Fantastic Art/Miró and Calder," Academy of Arts, Honolulu.
December: Shows at the Freddy Mayor Gallery, London.

1938 February: Shows at the Freddy Mayor Gallery, London.
October: Participates in the show "Trois siècles d'art aux Etats-unis" (Three Centuries of Art in the United States) at the Jeu de paume museum, Paris.
November: Retrospective at the George Walker Vincent Smith Gallery in Springfield, Massachusetts.

May 25, 1939 Birth of Mary Calder.
Calder composes an aquatic ballet for the World's Fair in New York.

1940 May: Shows at the Pierre Matisse Gallery, New York.
December: Shows jewelry at the Marian Willard Gallery, New York.

1941 March: Shows at the New Orleans Arts and Crafts Club.
May: Shows at the Pierre Matisse Gallery, New York.
December: Shows at the Marian Willard Gallery, New York.

1942 Meets Yves Tanguy and André Masson in New York.
Participates in the show "Artists for Victory" at the Metropolitan Museum of Art, New York.
October: Participates in the show "First Papers of Surrealism" at the Reid House, New York.

1943 September: Retrospective at the Museum of Modern Art, New York.
December: Shows jewelry at the Arts Club of Chicago.

1944 Illustrates *Three Young Rats and Other Rhymes* compiled by James Johnson Sweeney.

1945 Illustrates *The Rime of the Ancient Mariner* by Samuel Taylor Coleridge.
September: Shows gouaches at the Samuel M. Kootz Gallery, New York.
November: Shows sculptures at the Buchholz Gallery, New York.
Death of his father.

1946 Illustrates the English translation of the *Selected Fables* of La Fontaine. Creates the sets for *Balloons* by Padraic Colum.
October: Shows mobiles at the Louis Carré Gallery, Paris; catalogue introduction by Jean-Paul Sartre.

1947 Participates in the show "Le surréalisme en 1947" (Surrealism in 1947) at the galerie Maeght, Paris.

1948 September: Shows at the Ministerio do Educação, Rio de Janeiro.

October: Shows at the Museu de Arte, São Paulo.
Completes the *International Mobile* destined for the Philadelphia Museum, which refuses it; it is taken by the Museum of Fine Arts in Houston.

1949 Designs the sets for *Symphonic Variations* in Rio de Janeiro.
October: Shows at the Margaret Brown Gallery, Boston, and at the Virginia Museum of Fine Arts, Richmond.
November: Shows at the Bucholz Gallery, New York.

1950 Designs the sets for *Happy as Larry* by Donagh MacDonagh in New York.
June: Shows at the galerie Maeght, Paris.
October: Shows at the Stedelijk Museum, Amsterdam.
December: Shows at the Massachusetts Institute of Technology, Cambridge, Massachusetts.

1951 January: Shows at the Lefevre Galleries, London.
October: Shows with Miró at the Contemporary Museum, Houston.

1952 January: Shows at the Kurt Valentin Gallery, New York.
Designs the sets for Henri Pichette's play *Nucléa*, at the Théâtre National de Paris.
November: Shows at the galerie Maeght, Paris, and at Der Spiegel gallery, Cologne.

1953 Moves to Aix-en-Provence.
April: Shows at the Walker Art Center, Minneapolis.
May: Shows at the Frank Perls Gallery, Beverly Hills.
October: Shows with Naum Gabo at the Wadsworth Athenaeum, Hartford, Connecticut. Wins the prize of the biennale de São Paulo.

1954 Travels in the Near East.
October: Shows at the galerie Maeght, Paris.

1955 Shows in Bombay.
April: Participates in the show "Le Movement" (Movement) at the Denise René Gallery, Paris.
September: Shows at the Museo de Bellas Artes de Caracas.
Publication of *A Bestiary*.

1956 February: Shows at the Perls Galleries, New York.

1957 May: Shows at the Kunsthalle, Basel.

1958 Completes *Whirling Ear* for the World's Fair in Brussels, *Spirals* for UNESCO in Paris, and *.125* for Idlewild International Airport (now John F. Kennedy Airport), New York.

1959 March: Shows at the galerie Maeght, Paris.
Participates in the show "18 Living Artists" at the Whitney Museum, New York.
May: Shows at the Stedelijk Museum, Amsterdam.

1960 February: Death of his mother.
March: Shows at the Klaus Perls Galleries, New York. Completes a tapestry at the Aubusson factory.

1961 February: Shows with Miró at the Klaus Perls Galleries, New York.
"Motion in Art," traveling show beginning at the Stedelijk Museum, Amsterdam.

1962 Designs the sets for *The Glory Folk* by John Butler at the Spoleto festival. Completes the stabile *Teodelapio* at Spoleto. Installation of the motorized mobile *Four Elements* in front of the Moderna Museet, Stockholm.
July: Retrospective at the Tate Gallery, London.
December: Retrospective at the Musée des Beaux-Arts, Rennes.

1963 June: Participates in *Documenta III* in Kassel.
October: Shows at Grosvenor Gallery, London. Shows circus drawings at the Perls Galleries, New York. Installation of the stabiles *Anteater*, in Rotterdam, and *Bucephalus*, in Fresno, California.
November: Show "Circus, Drawings, Wire Sculptures and Toys" at the Museum of Fine Arts in Houston. Retrospective at the Solomon R. Guggenheim Museum, New York.

1965 July: Retrospective at the Musée National d'Art Moderne, Paris.
November: Installation of *Le Guichet* at the Lincoln Center for the Performing Arts, New York. Completes the sets for the ballet "Et pourtant elle tourne" (And Yet It Turns) at the Opéra de Marseille.

1966 February: Shows at the galerie Maeght, Paris. Gift of *Object in Five Planes (Peace)* to the U.N. headquarters, New York. Publication of his autobiography. Installation of *Big Sail* at the Massachusetts Institute of Technology.
June: Retrospective at the Krugier Gallery, Geneva.
September: Shows gouaches at the ICA, London.
November: Shows jewelry at the Perls Galleries, New York.

1967 Completes *Three Discs* for the World's Fair in Montreal. Installation of *Spunk of the Monks* in Des Moines, Iowa.
February: Shows at the Museum of Modern Art, New York.
May: Retrospective at the Akademie der Künste, Berlin.

1968 February: Creates *Ballet Without Dancers* for *Work in Progress* at the Rome Opera.
March: Retrospective at the Maison de la culture in Bourges, France.
April: Retrospective at the Fondation Maeght, Saint-Paul-de-Vence, France, and gift of *Feathering (Empennage)* (1953).
October: Shows mobiles at the galerie Maeght, Paris.
Installation of the motorized mobile *Red, Black and Blue* at the Dallas airport.

December: Installation of the stabile *El Sol Rojo* (The Red Sun), at the Aztec Stadium in Mexico.

1969 Spring: Installation of *Gwenfritz* at the Smithsonian Institution, Washington, D.C. Installation of *Three Discs—One Missing* (1964) at the Penn Center Plaza in Philadelphia. Sets for the ballet *Métaboles* at the Théatre de l'Odéon, Paris.
April: Retrospective at the Fondation Maeght, Saint-Paul-de-Vence, France.
July: Show, "Calder in Venezuela," in Caracas.
September: Shows at the Fête de l'Humanité. "Salute to Alexander Calder" at the Museum of Modern Art, New York.

1970 The *Cirque Calder* installed at the Whitney Museum, New York.
Installation of *Red Skin/Indiana (Peau rouge/Indiana)* in front of the University of Indiana at Bloomington.

1971 February: Shows at the galerie Maeght, Paris.
June: Retrospective at the Musée Toulouse-Lautrec, Albi, France.
October: Shows Aubusson tapestries at the Whitney Museum, New York.
Publication of Jacques Prévert's book, *Calder*, with seven etchings.
Sets and costumes for *Amériques* (Americas), a ballet with music by Edgar Varèse, at the Ballet-Théâtre contemporain d'Amiens, France.

1972 Completes *Eagle* for the Fort Worth National Bank, Texas.
November: Shows with Miró in Tokyo and Basel. Special issue of *XXᵉ siècle: Hommage à Alexandre Calder* (Twentieth Century: Homage to Alexander Calder).

1973 Retrospective at the galerie Maeght, Zurich.
Installation of *Stegosaurus* on the Alfred E. Burr Mall, Hartford.
October: Shows at the Perls Galleries, New York.
December: Shows at the Whitney Museum, New York. Paints *Flying Colors*, a DC-8 airplane, for Braniff International Airlines.

1974 October: Shows at the Perls Galleries, New York. Installation of *Universe* and *Flamingo*, Chicago.

1975 May: Retrospective at the Haus der Kunst, Munich.
Installation of *Collapsible Elements* in Wichita, Kansas.

1976 Installation of *The Red Spider* at la Défense, Paris.
April: Installation of *Gallows* and *Lollipops* (1962) at Yale University, New Haven.
October: Tribute to the artist in Philadelphia with the installation of the mobile mural *White Cascade*, a show of tapestries, and the re-creation of *Socrate* (Socrates) by Erik Satie. Retrospective at the Whitney Museum, New York, "Calder's Universe."
November 11: Death of Calder.

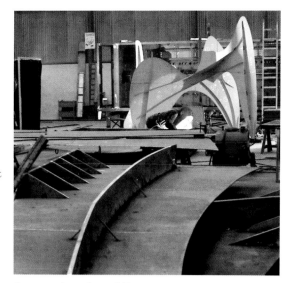
Construction of a stabile

It All Began with the *Cirque Calder*

When he arrived in France in 1926, Calder began to lay the foundations for the *Cirque Calder*. The use of everyday, whimsical materials allowed him to verify different plastic hypotheses. Interest in new materials also dissuaded him from pursuing his first attempts in woodcarving or bronze casting. Instead, he focused on wire figures.

Calder quickly discovered the leaders of the radical avant-garde, the Abstraction-Création group. Under their influence, Calder soon began to explore the theories of Boccioni and Moholy-Nagy, imagining the sculpture of the future—a sculpture in motion. Calder motorized some of his creations, but eventually abandoned this approach in order to define a sculpture capable of engendering itself through the sophisticated play of equilibriums and disequilibriums, using weights and counterweights.

Calder was not doctrinaire, however, and the spirit of his sculpture evolved rapidly during the course of the 1930s. Drawing from the Surrealist repertoire allowed him freedom in the association of disparate forms and materials, as well as the means of producing a poetic language that rejected the rigorous formalism of his contemporaries.

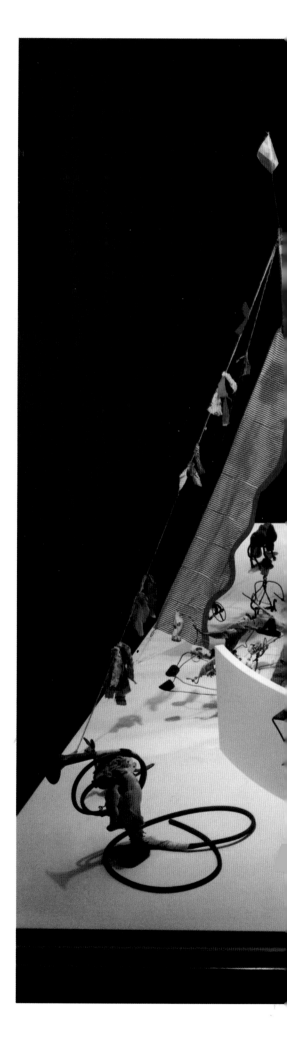

1 Caniche, *1932*

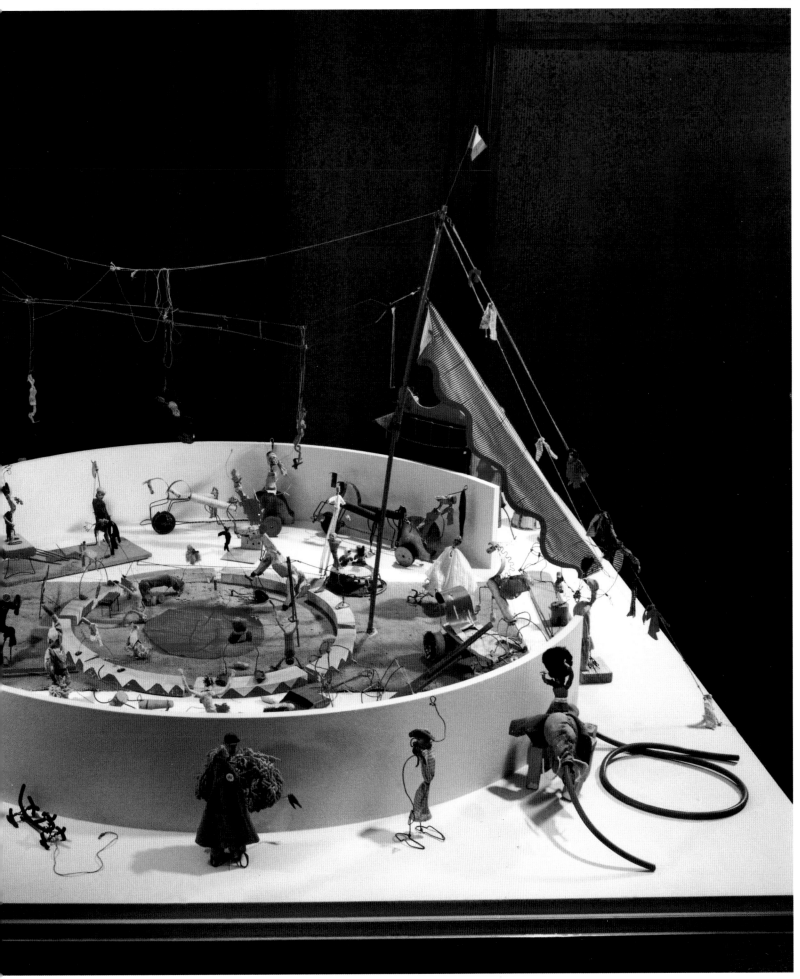

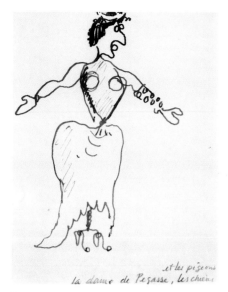

3 Dame de pegase, *circus drawing*

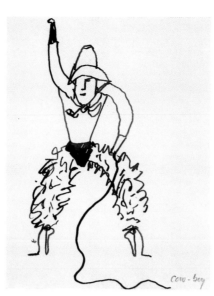

4 Cowboy, *circus drawing*

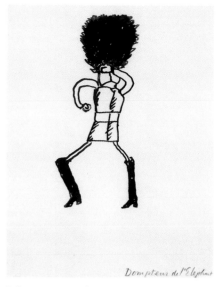

5 Dompteur de l'éléphant, *circus drawing*

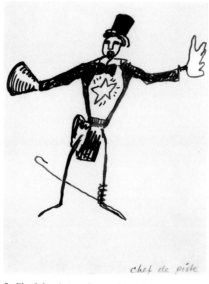

6 Chef de piste, *circus drawing*

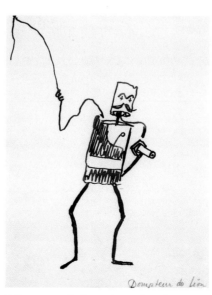

7 Dompteur du lion, *circus drawing*

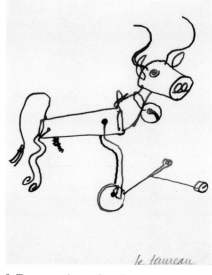

8 Taureau, *circus drawing*

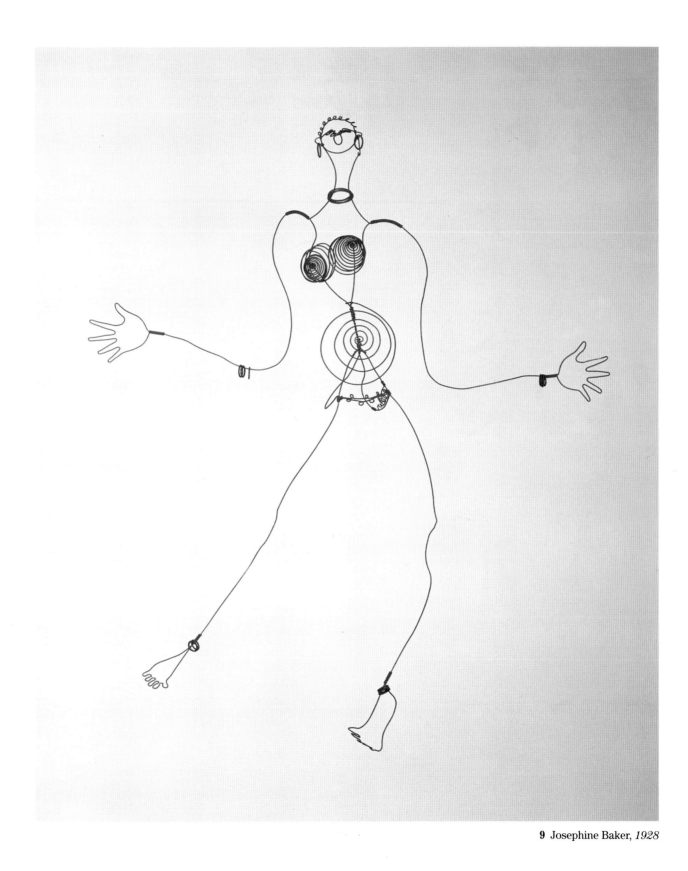

9 Josephine Baker, *1928*

10 *Untitled, c. 1936*

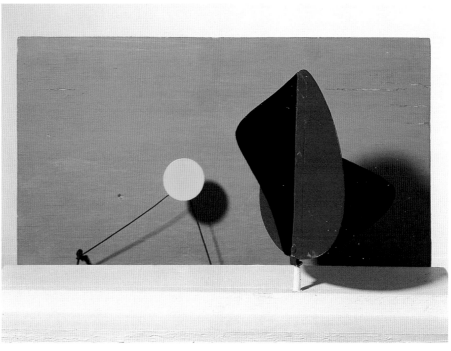

11 Petit panneau bleu/Little Blue Panel, *c. 1938*

12 *Untitled* (Day and Night), *c. 1937*

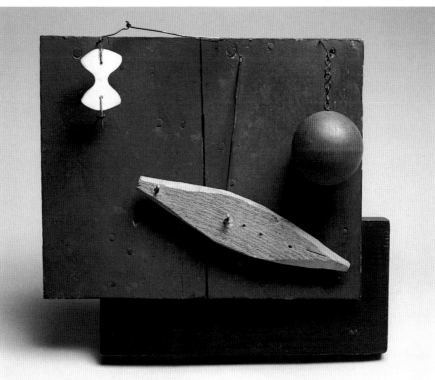

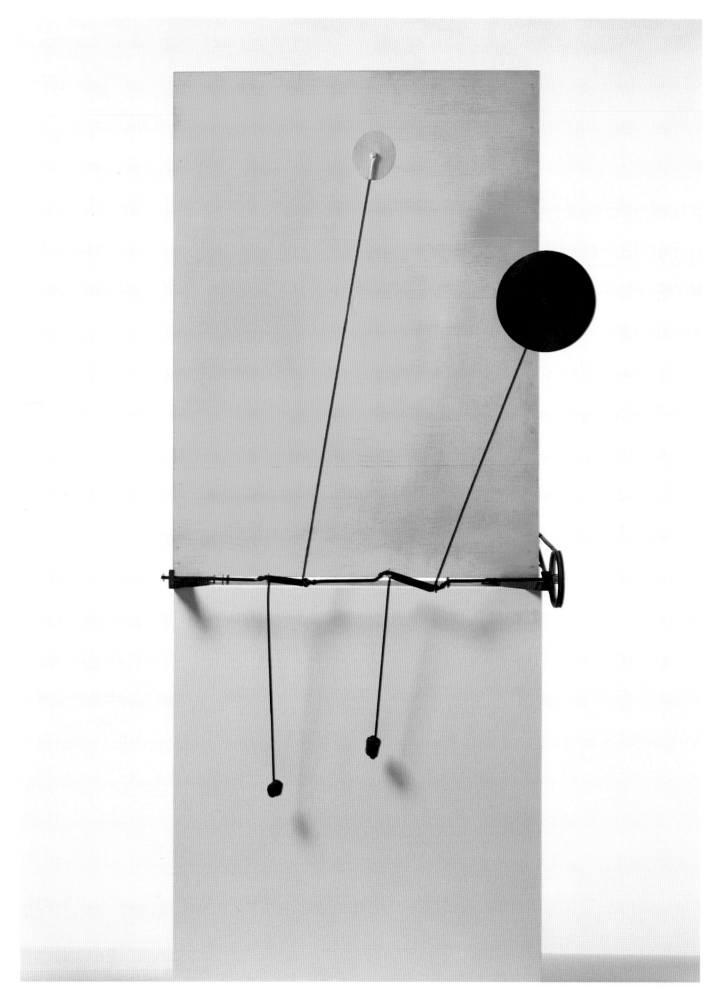

13 Yellow Panel, *c. 1940–41*

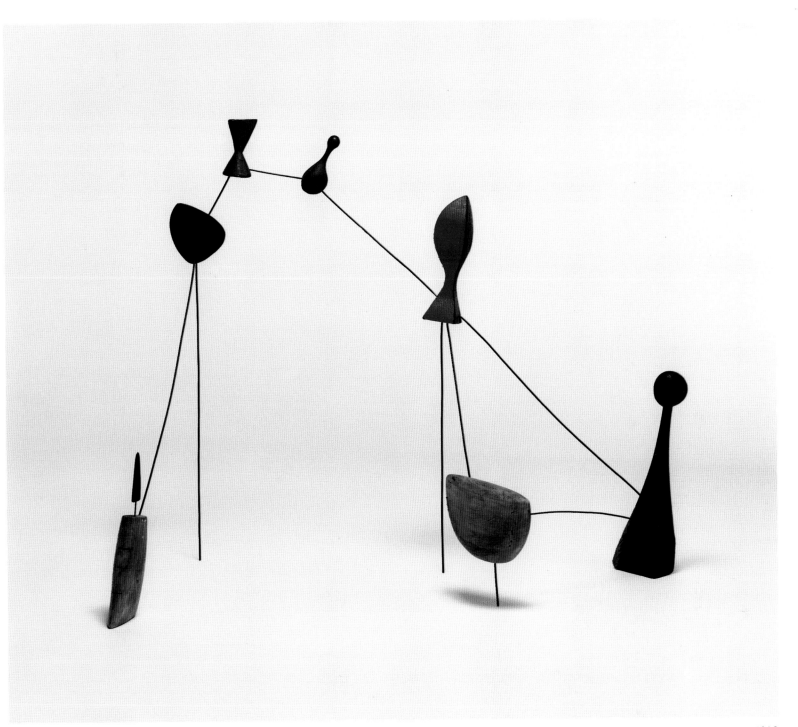

14 Constellation with Sundial, *c. 1943*

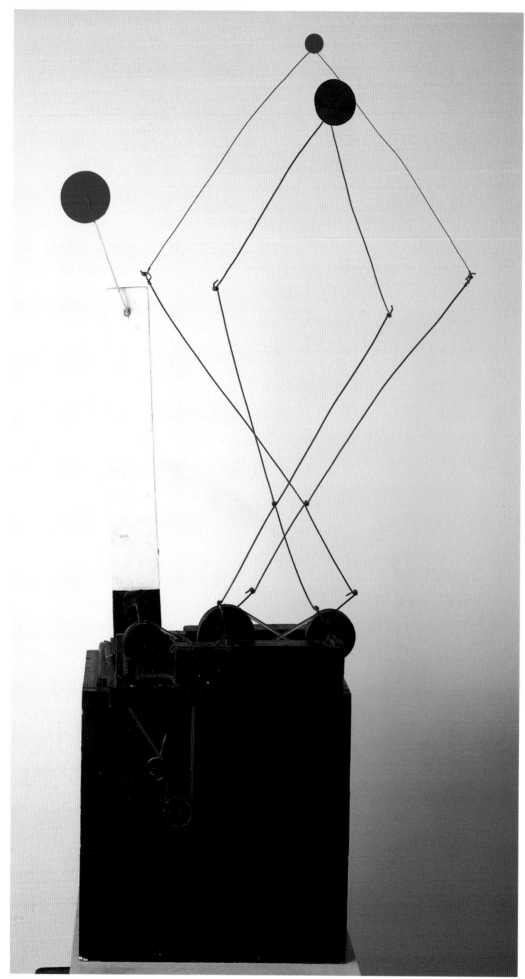

15 Mobile (Pantograph), *1931*

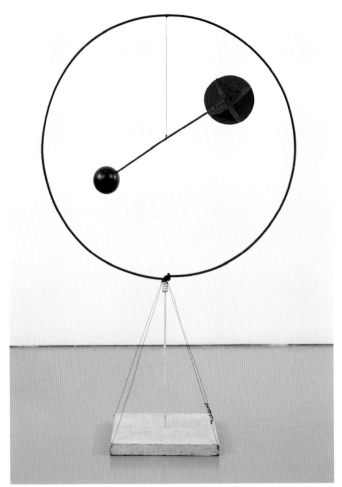

16 *Untitled, c. 1931*

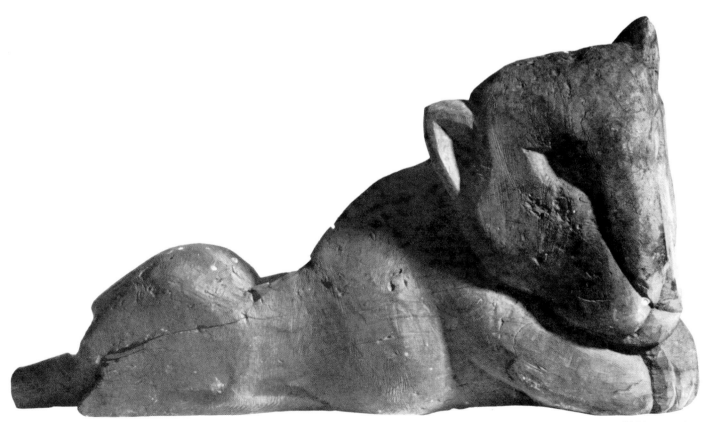

17 Lionne, *1929*

The "Big Space"

In the sculpture he showed at the Percier Gallery in 1931, Calder began to discover the principles which would lead to his mobiles. In his autobiography he noted, "[I] had been working on things with a little motion, some with more motion. I had quite a number of things that went round and round, driven by a small electric motor—some with no motors—some with a crank" (Calder, p. 126). Marcel Duchamp gave the name "mobile" to this kind of sculpture in 1932. That same year, Calder unveiled *Dancing Torpedo Shape* in painted wood and wire and equipped with a small motor. "In addition to something that moves," noted Calder, "in French it [*mobile*] also means motive" (Calder, p. 127). Calder's *Constellations* reflect his fascination with various sculptural elements in motion. He made subtle calculations to control his machine-like sculptures. Such manipulation gave his objects free and ever-changing qualities that play on the viewer's imagination.

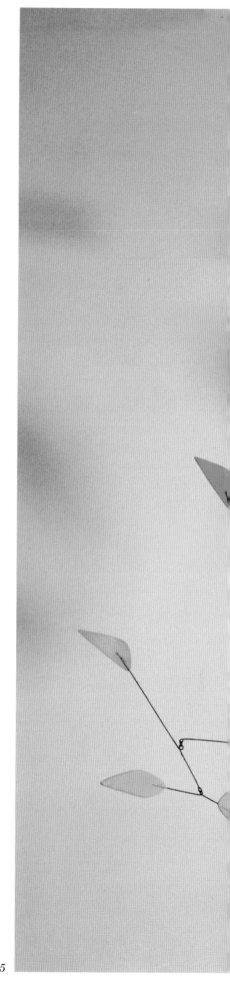

18 Mobile sur deux plans, *c. 1955*

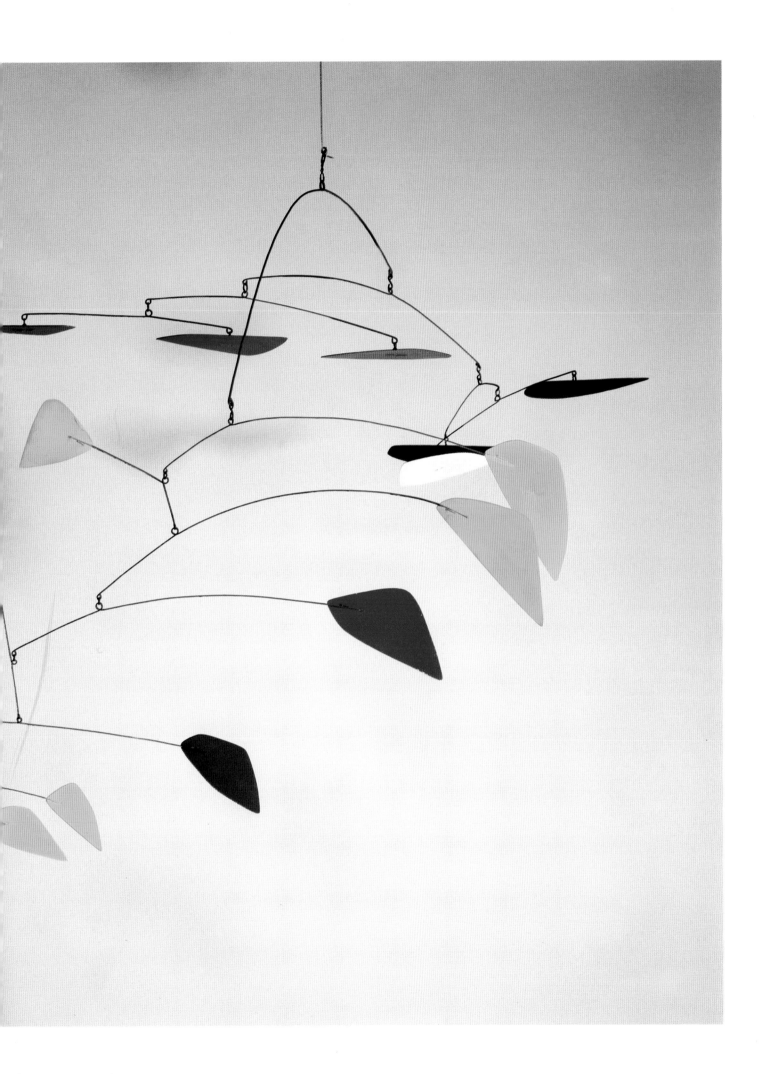

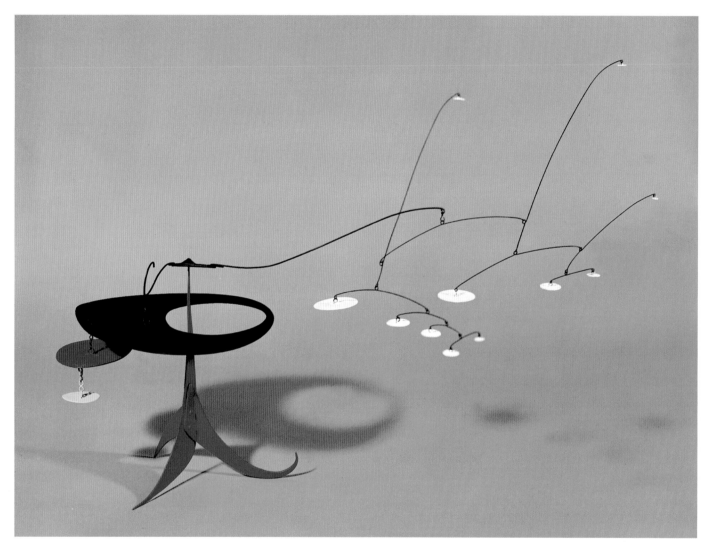

19 Dancing Stars, *c. 1945*

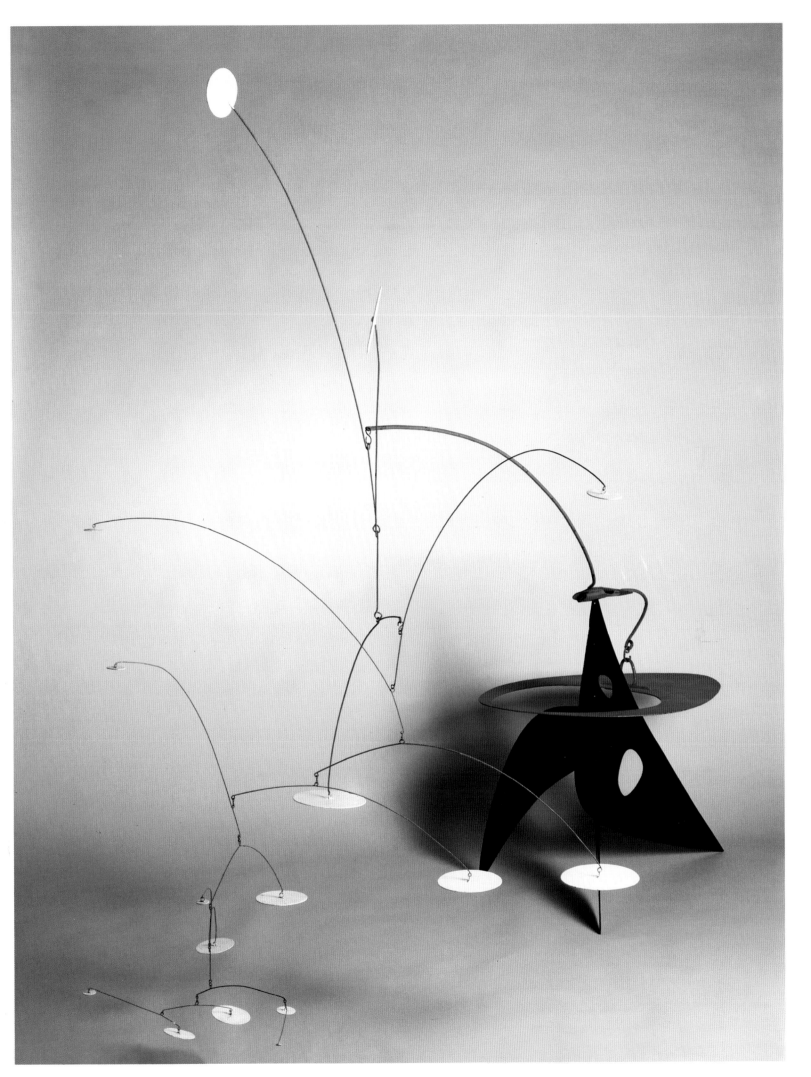

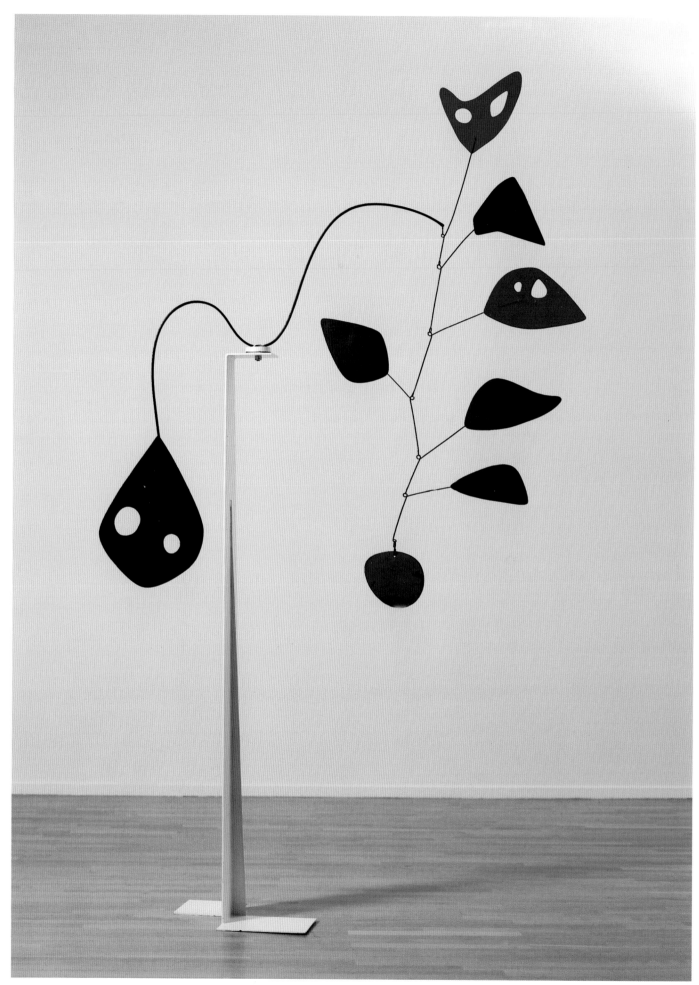

21 Bird on the Tree Branch, *1949*

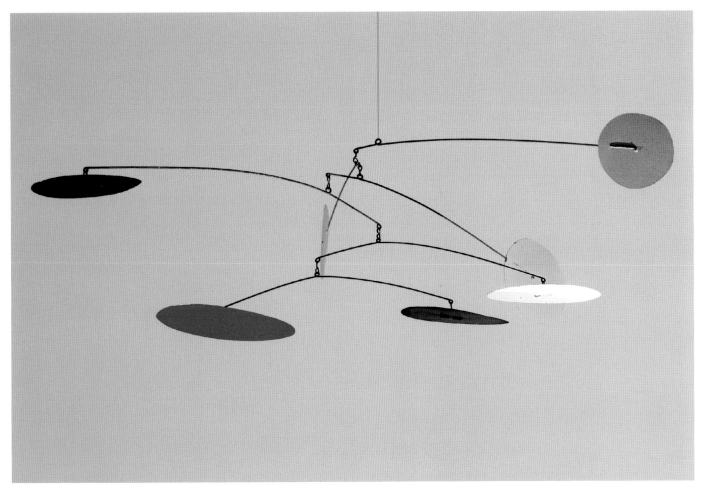

22 Trois soleils jaunes, *1965*

23 Four Discs Red Counterweight, *1975*

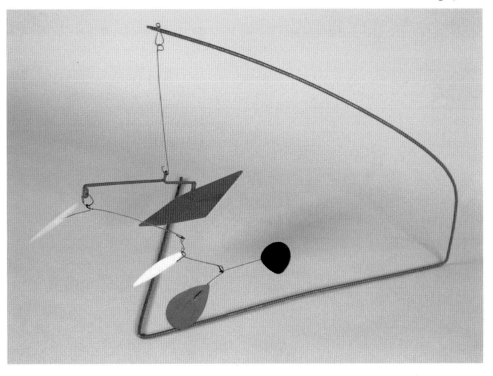

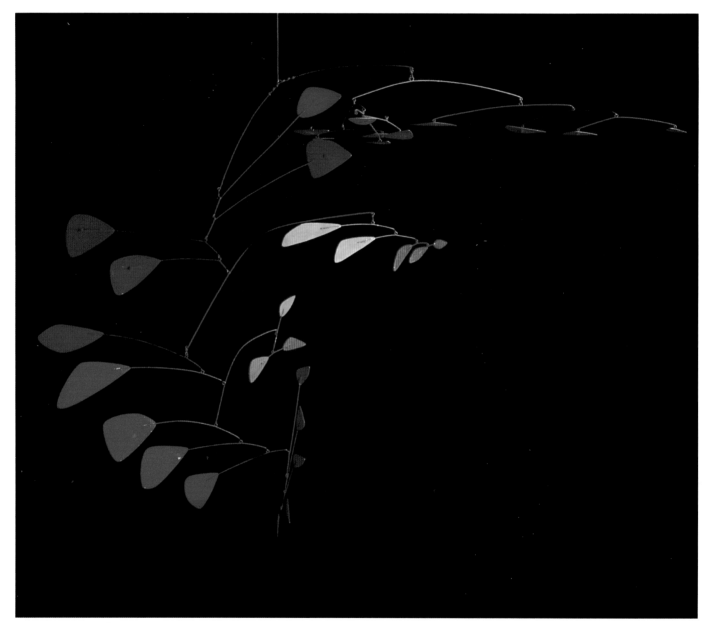

24 Sumac V, *1953*

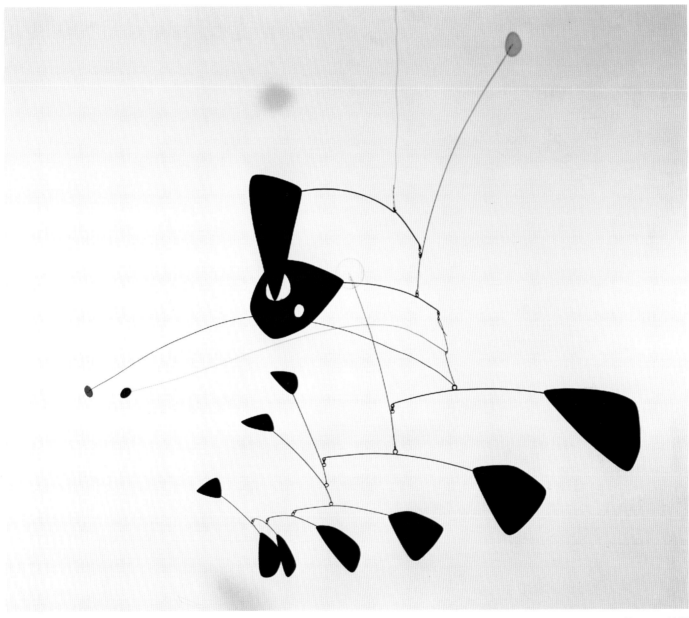

25 Antennae with Red and Blue Dots, *c. 1953*

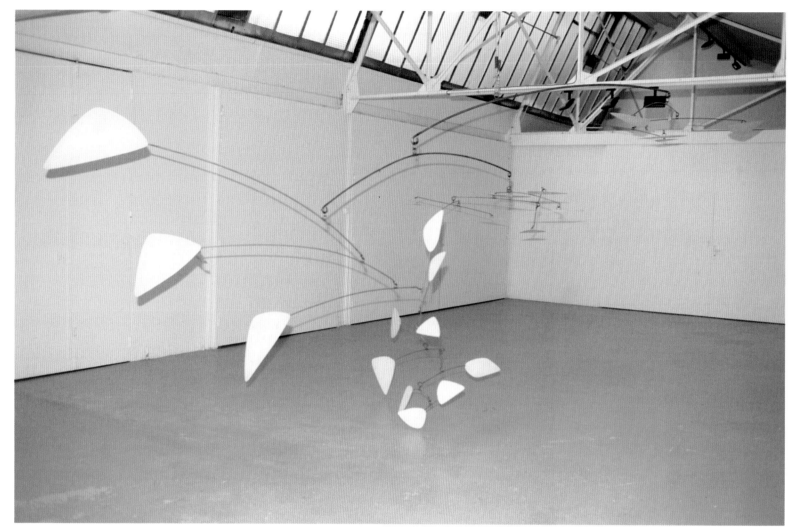

26 Spider Web, *1965*

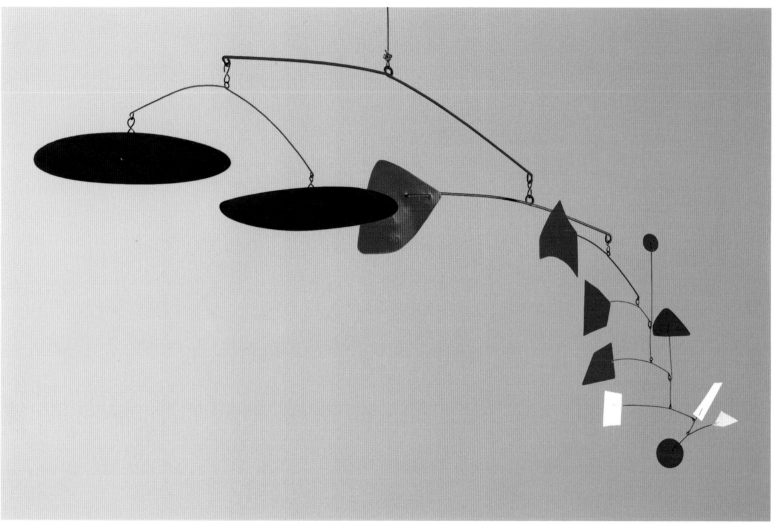

27 *Untitled, 1970*

Sculpture Like a Cathedral

While Calder was obsessed with plastic dynamism and made his works into kinetic machines, he also attempted static sculpture that would possess the same revolutionary quality. As odd as it may seem, the artist was late in envisioning the sculpture that was the complement to his mobiles. It was Jean Arp who baptized such contrasting works "stabiles." The ancestor of the stabiles is certainly *Gothic Construction from Scraps* (1939), for which Calder apparently was inspired by the Middle Ages. He reinterpreted the structure of Gothic architecture, with its pillars, arches, and, above all, massive buttresses. Calder showed this creation for the first time in New York, but only came to a complete, formal definition of the stabile with *Black Beast* (1940).

Made out of steel and painted black, stabiles are characterized by sharp angles, wide, arching vaults, and straight, bending, and broken lines, that stand out against the surrounding space. The many commissions he received beginning in the 1940s allowed Calder not only to create works of an impressive size, but also to explore all their plastic possibilities. He did not limit his output to figurative sculptures; instead, he introduced works very different in spirit and physical appearance into his aesthetic perspective. Some are almost abstract, such as *The Red Spider* (1972), and some illustrative, such as *Saurien* (1975) or the Crags and the Critters series (1974).

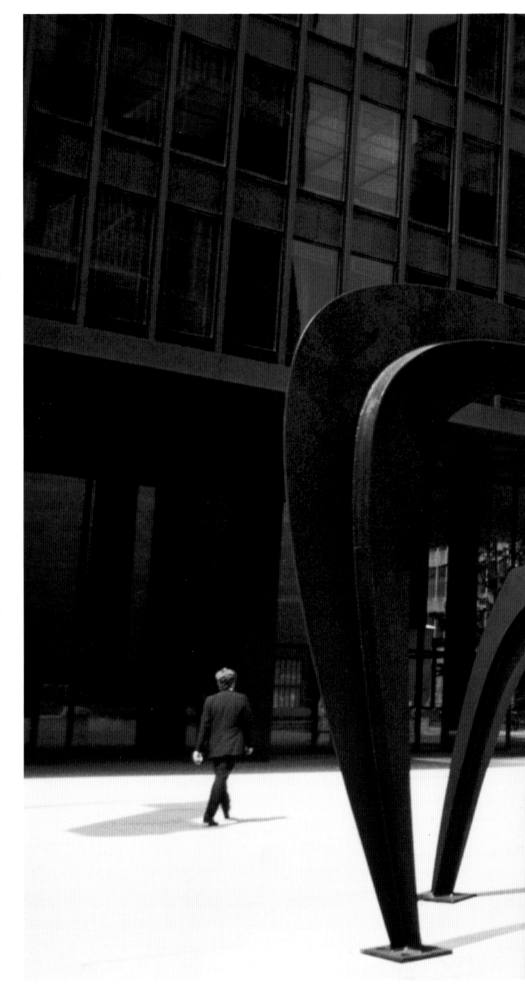

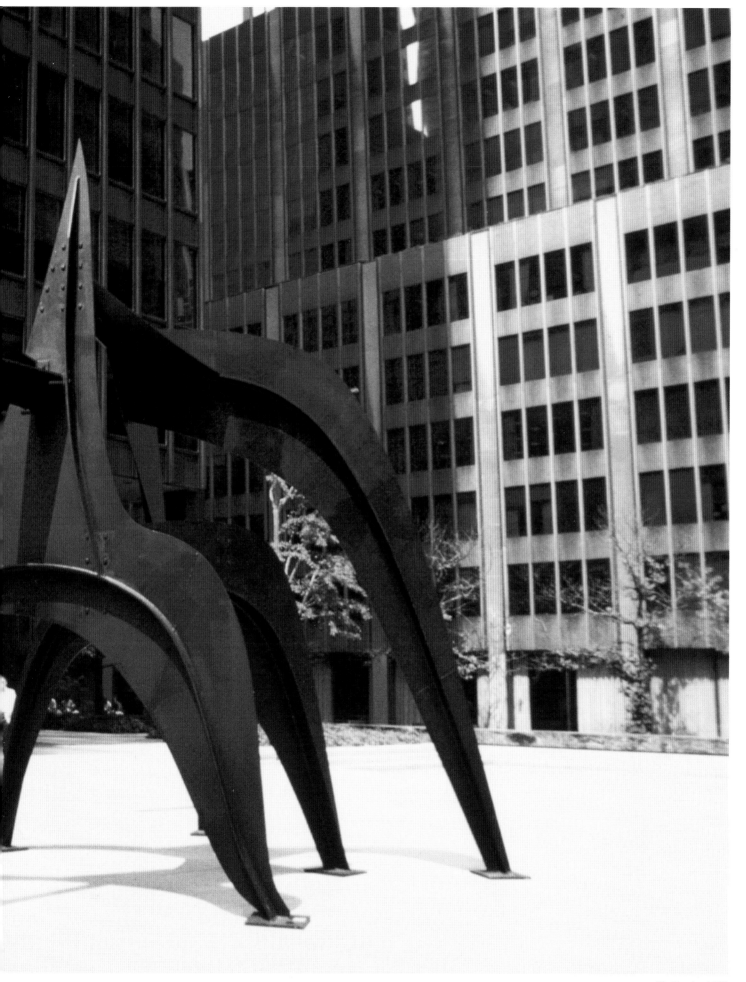

28 Tom's, *1974*

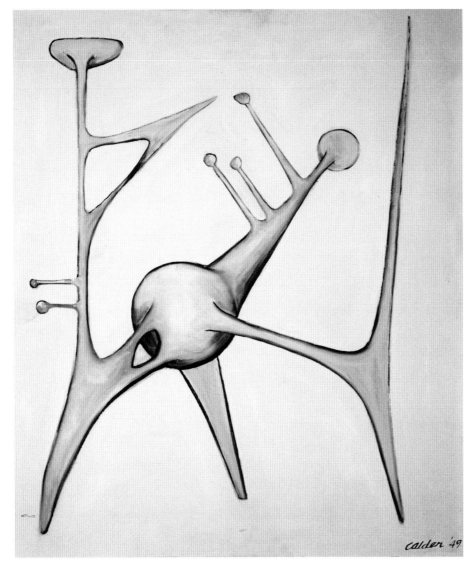

29 Stabile, *1949*

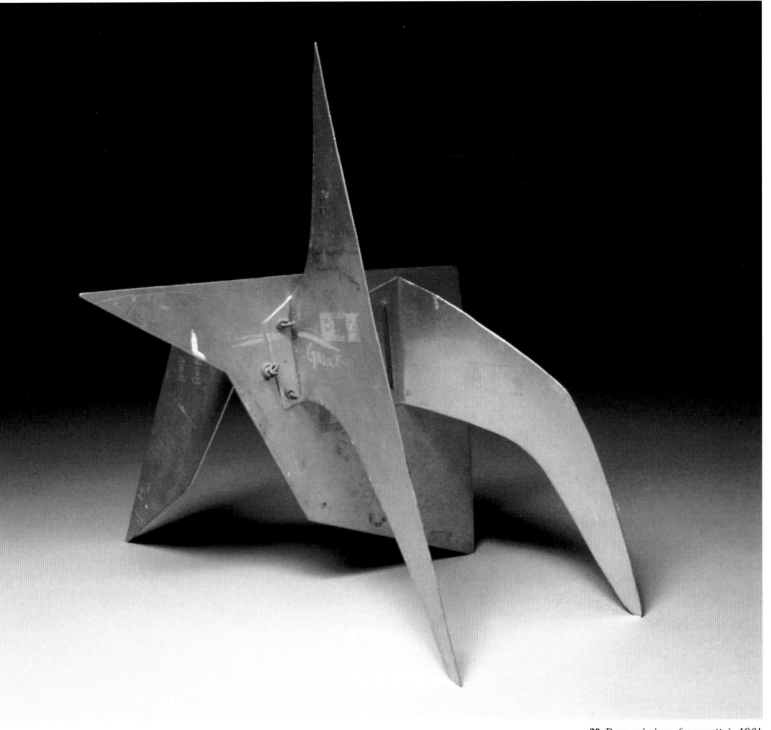

30 Porc qui pique *(maquette), 1964*

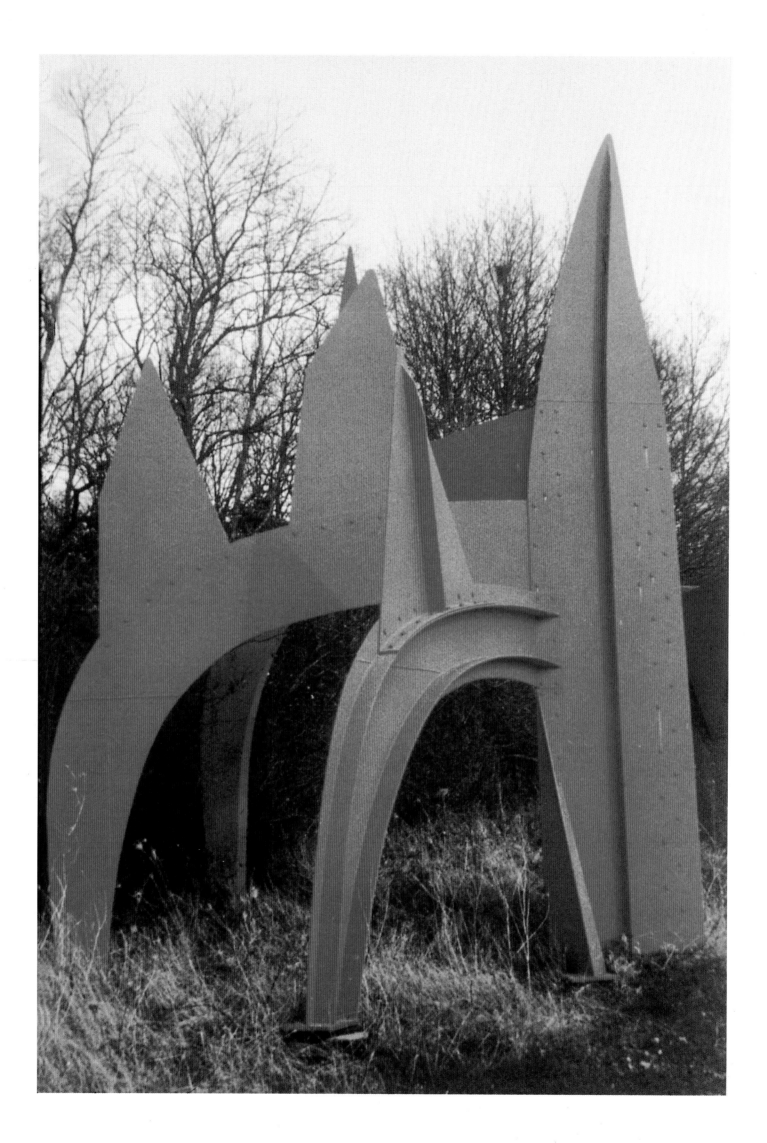

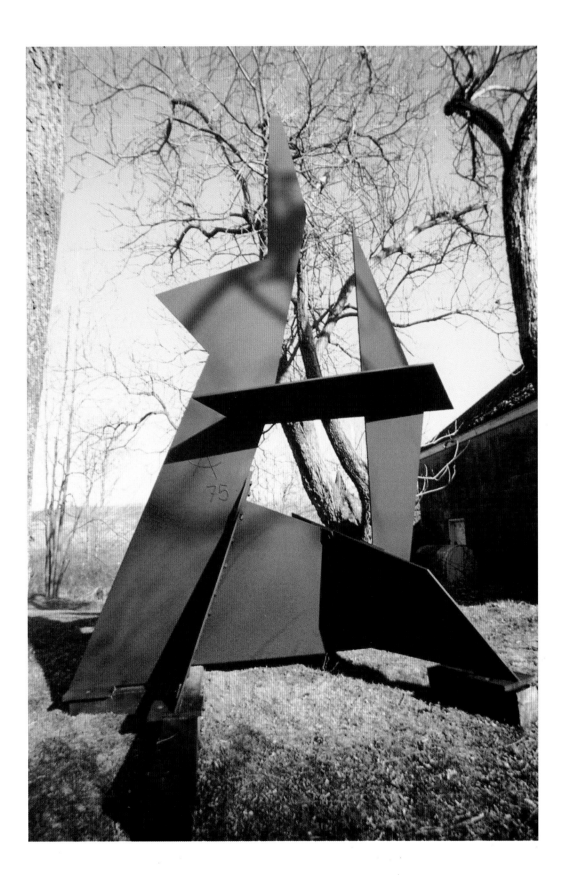

Opposite:
31 Saurien, *1975*

Right:
32 Angulaire, *1975*

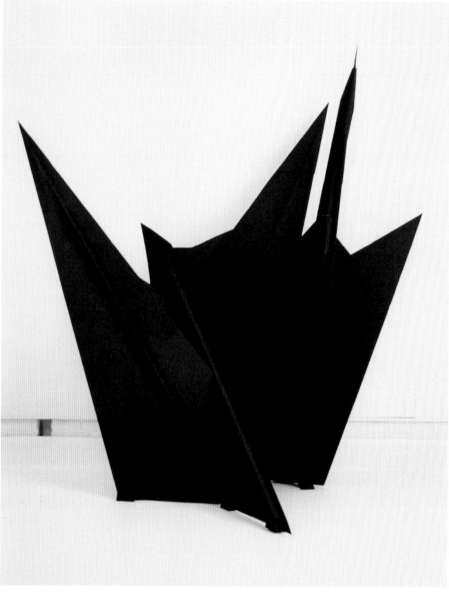

33 Objects in Five Planes/Peace, *1965*

34 Peau Rouge *(intermediate maquette), 1969*

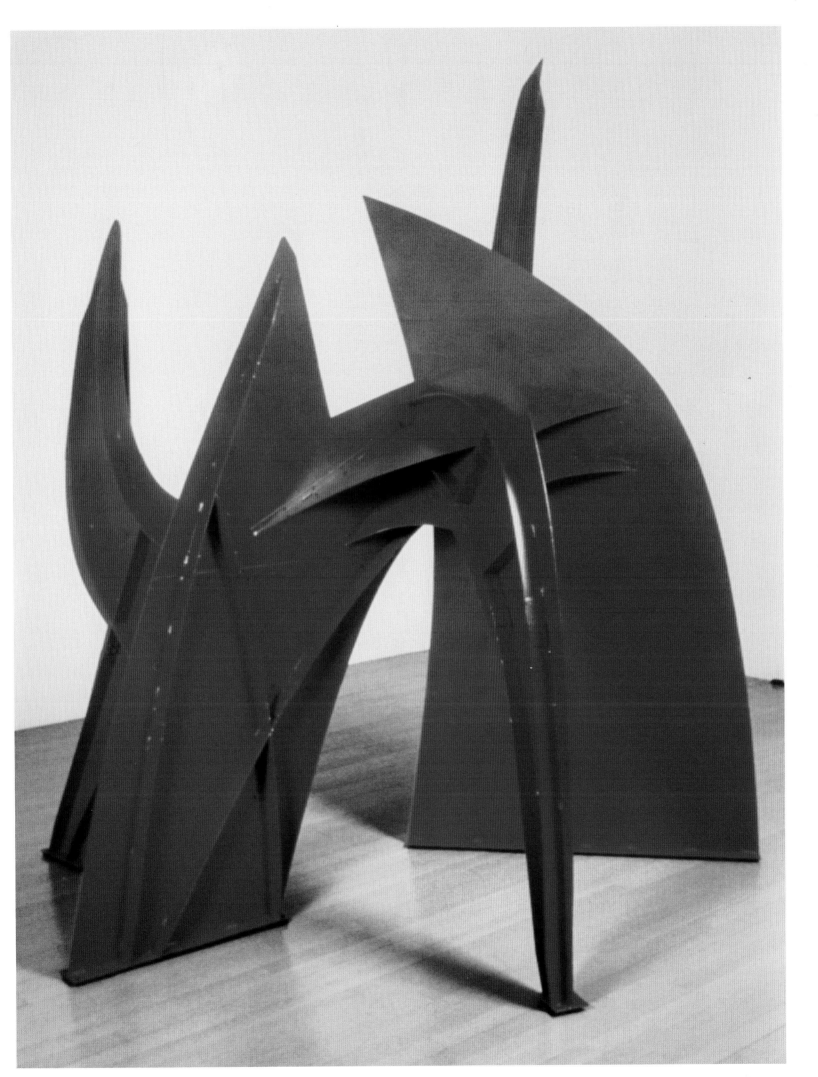

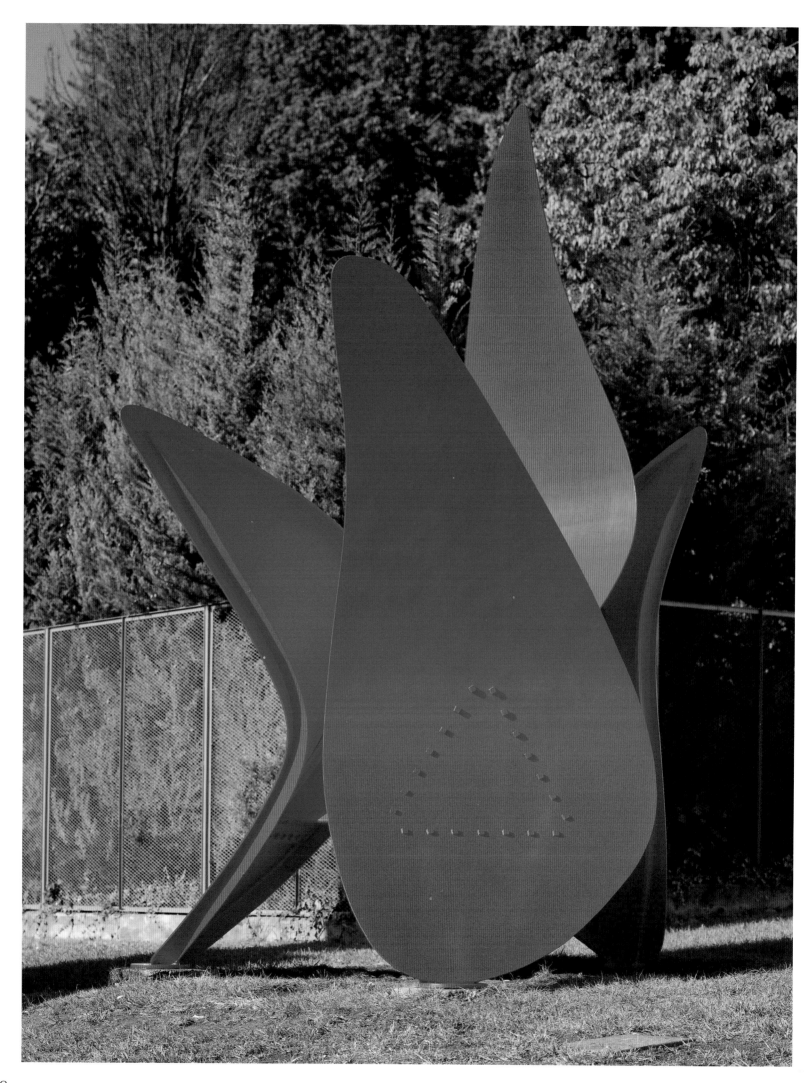

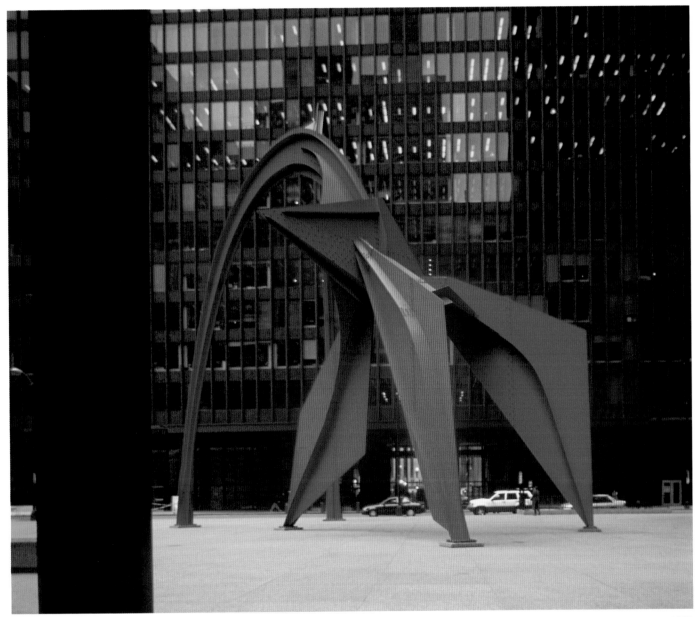

36 Flamingo, *1973*

Opposite:
35 Four Wings, *1972*

37 Les renforts *(maquette), c. 1962*
38 Trois bollards *(maquette), 1969*

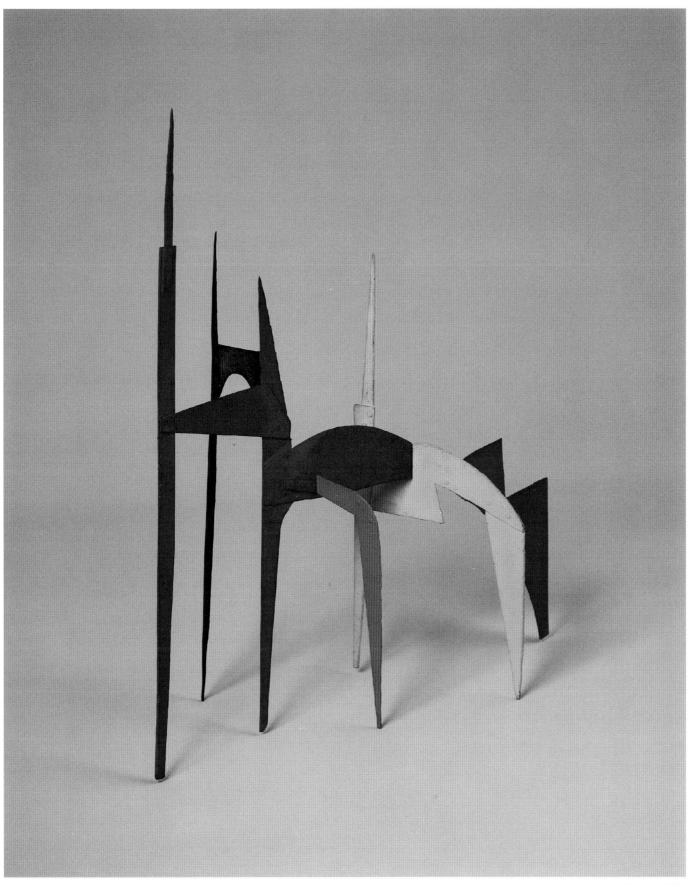

39 Gothic Construction from Scraps, *1939*

At Once Apollonian and Dionysian

The polarity of the mobiles and stabiles led Calder to imagine a third generation of works that combines the two. This marriage of static and dynamic elements appears in Calder's sculptures of the early 1930s, but it was primarily requirements of their construction that produced this effect. Calder searched for an equilibrium and a harmony between two opposite intentions with *Spider* (1939), *Lily of Force* (1945), Untitled *(Duck)* (1943), and the magnificent *Machine cycloïdale* (c. 1946). His standing mobiles offered him an almost limitless field of exploration, leaving him free of all constraint. *Flamande* (1953), and *Myxomatose* (1953) may be regarded as the prototypes of this family of open-air sculptures. Calder, however, never disdained works based on the principles of mobiles mounted on a base or fixed foot, as in *Le disque bas* (Low Disc, 1962), and *Beggar's Penny* (1962).

40 Two Moons, *1969*

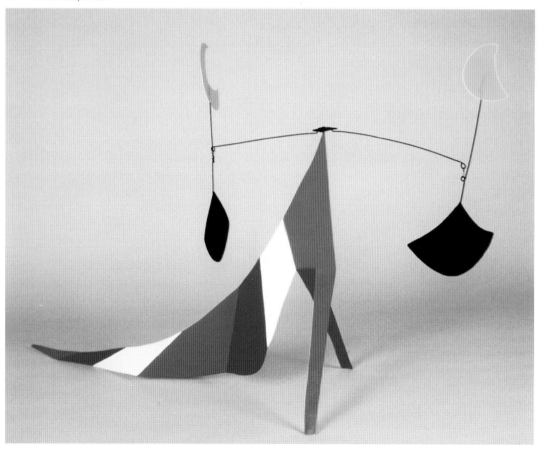

Opposite:
41 Five Empties/Three Up Three Down, *c. 1973*

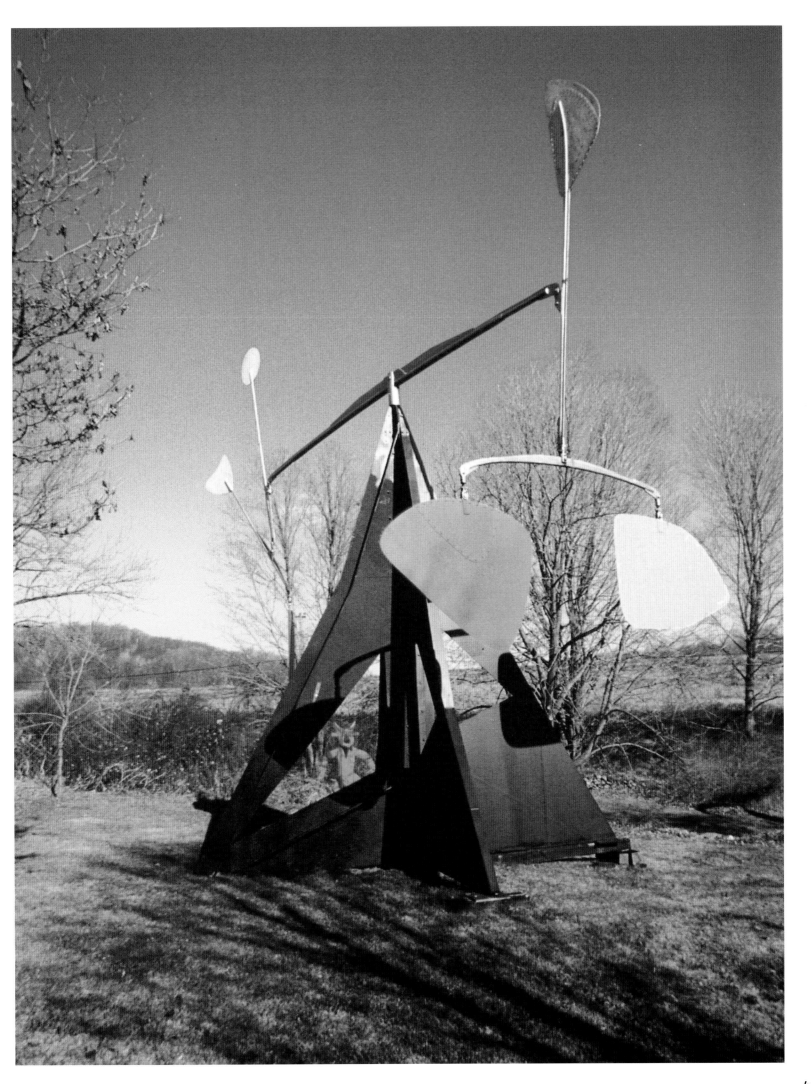

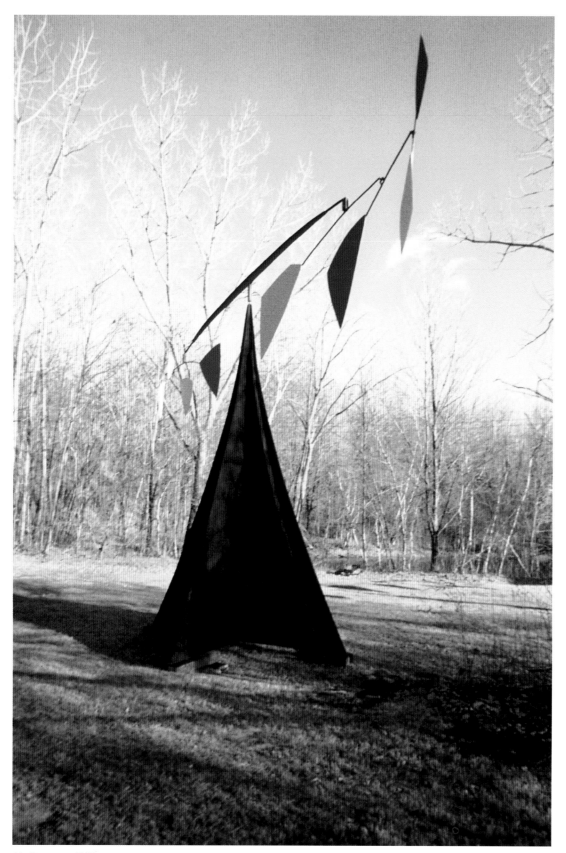

42 Carmen, *1974*

Opposite:
43 Small Crinkly, *1976*

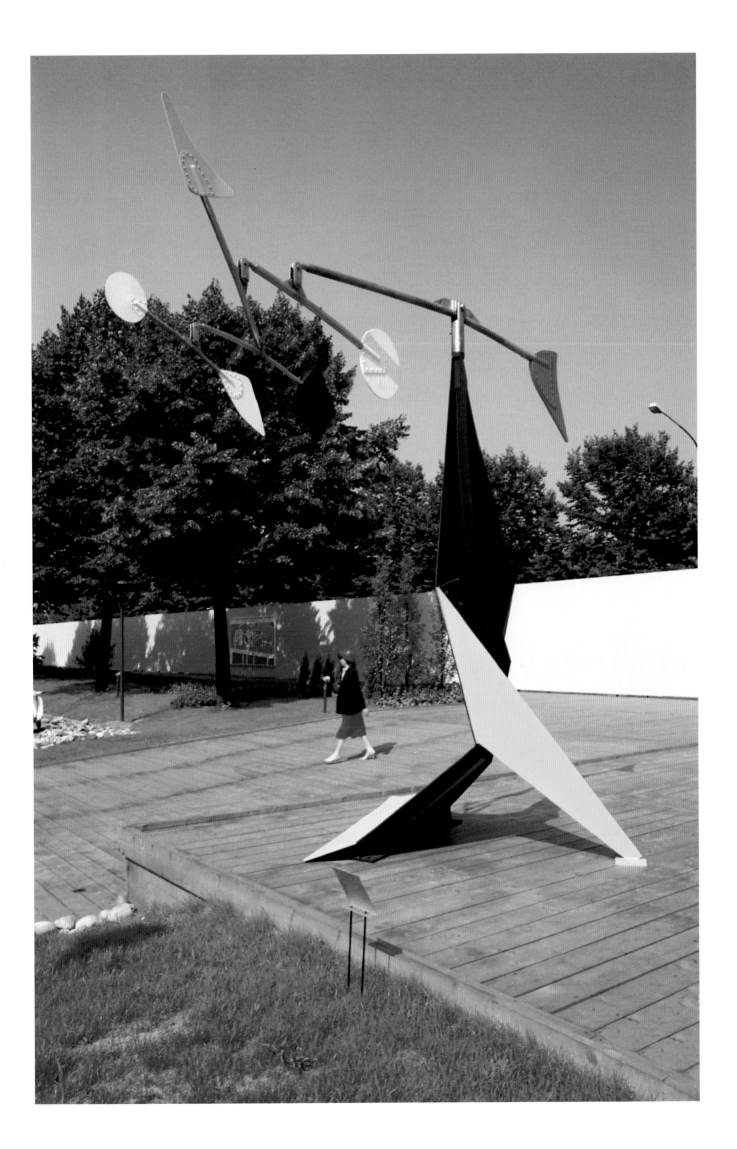

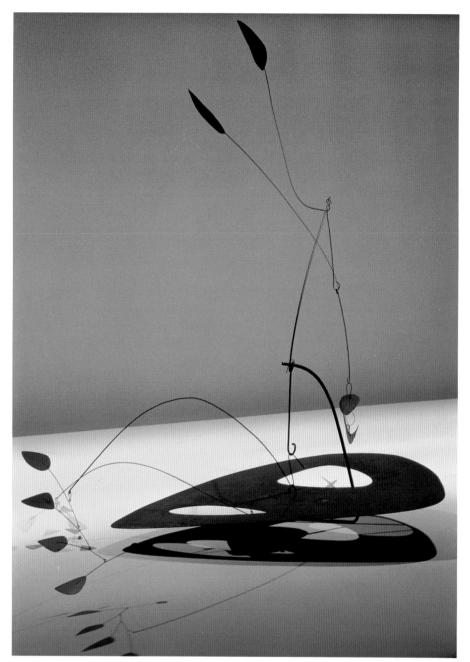

44 Lily of Force, *1945*

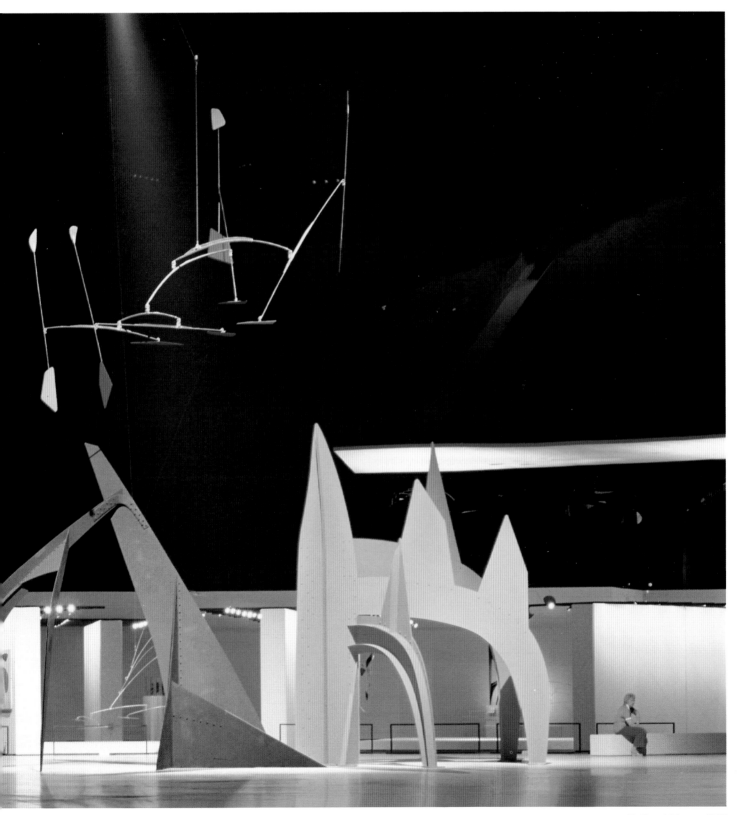

45 Sorel Horse, *1975*

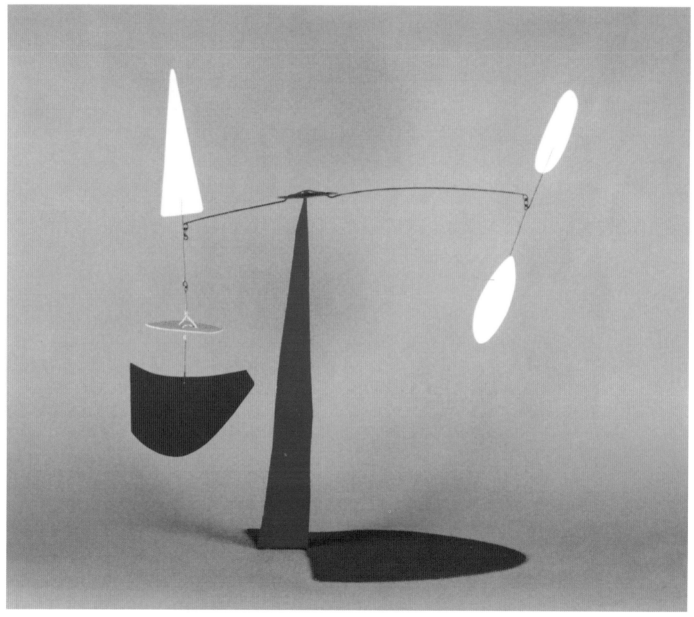

46 Horizontal Yellow, *1972*

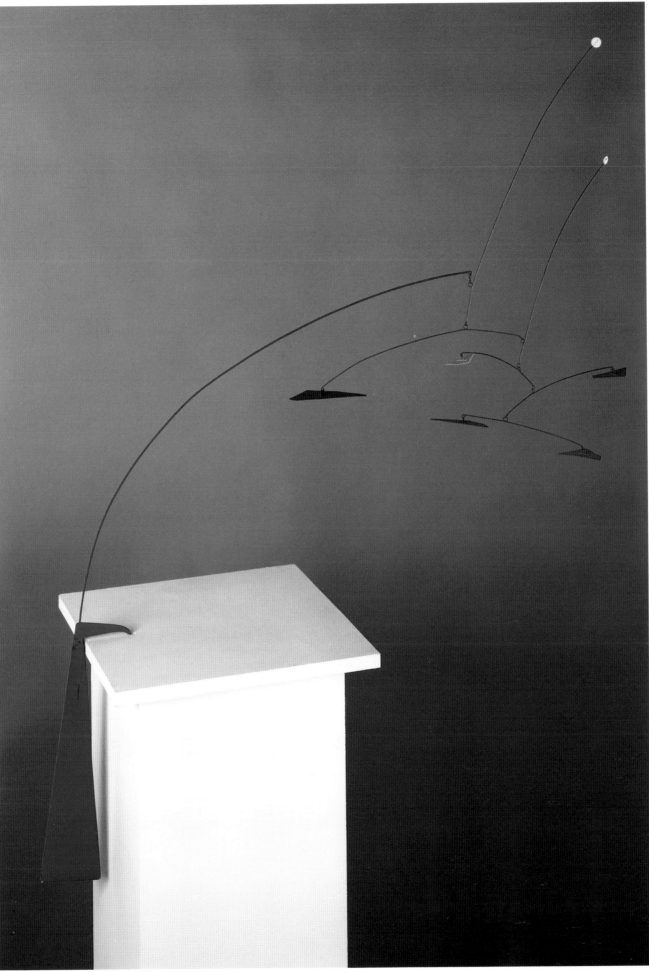

47 Under the Table, *1952*

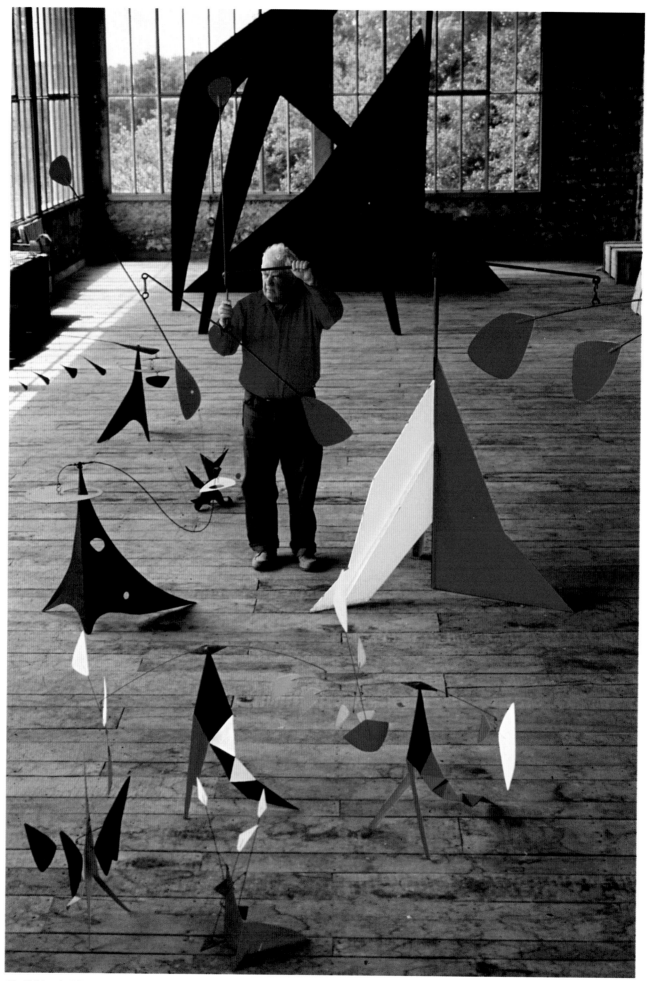

48 *Calder in his studio, Saché, August 1967*

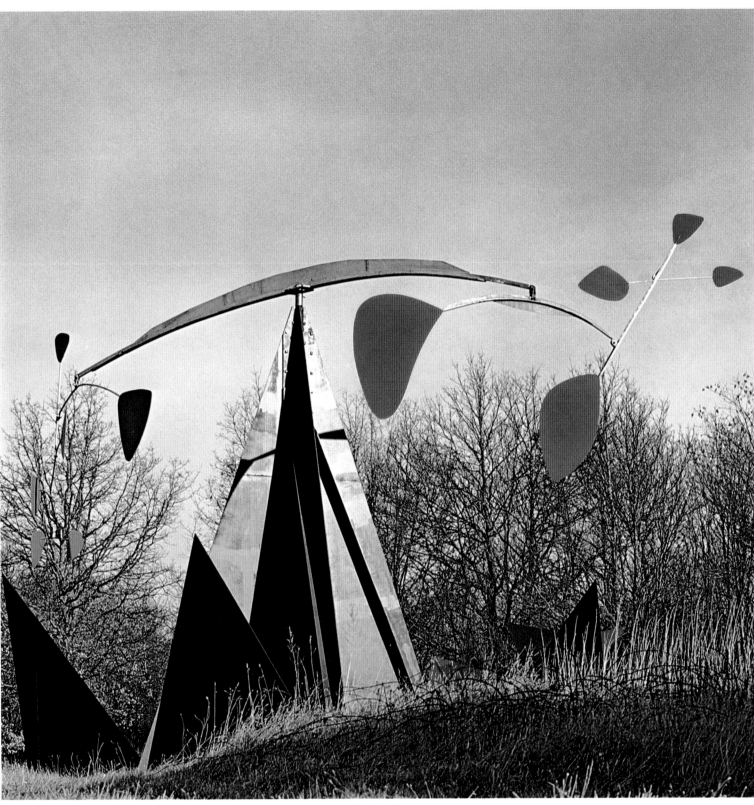

49 Reims croix du sud, *1969*

A Prolific Artist

While vacillating between several formal solutions and techniques, Calder successfully tried his hand at wood and bronze sculpture. Even as his style matured, Calder made forays into unexpected areas, never restricting himself to abstract sculpture. He designed decorative sets, such as the *Mercury Fountain* for the Spanish pavilion of the World's Fair (Paris, 1937), and painted the fuselages of airplanes in *Flying Colors.*

Calder's fame is based on only a portion of his oeuvre. Beside the mobiles and stabiles, however, he produced important etchings and many lithographs, as well as colored and caricatural gouaches such as *Man and Woman,* (1966) and *Les Affreux* (1968). Moreover, he pursued toymaking and jewelry design from a sculptural vantage point in the 1940s. His workshop at Saché gives an idea of the prolific nature of his work, which endlessly draws upon itself.

50 Mercury Fountain, *1937, for the Spanish Pavilion of the Paris Exposition*

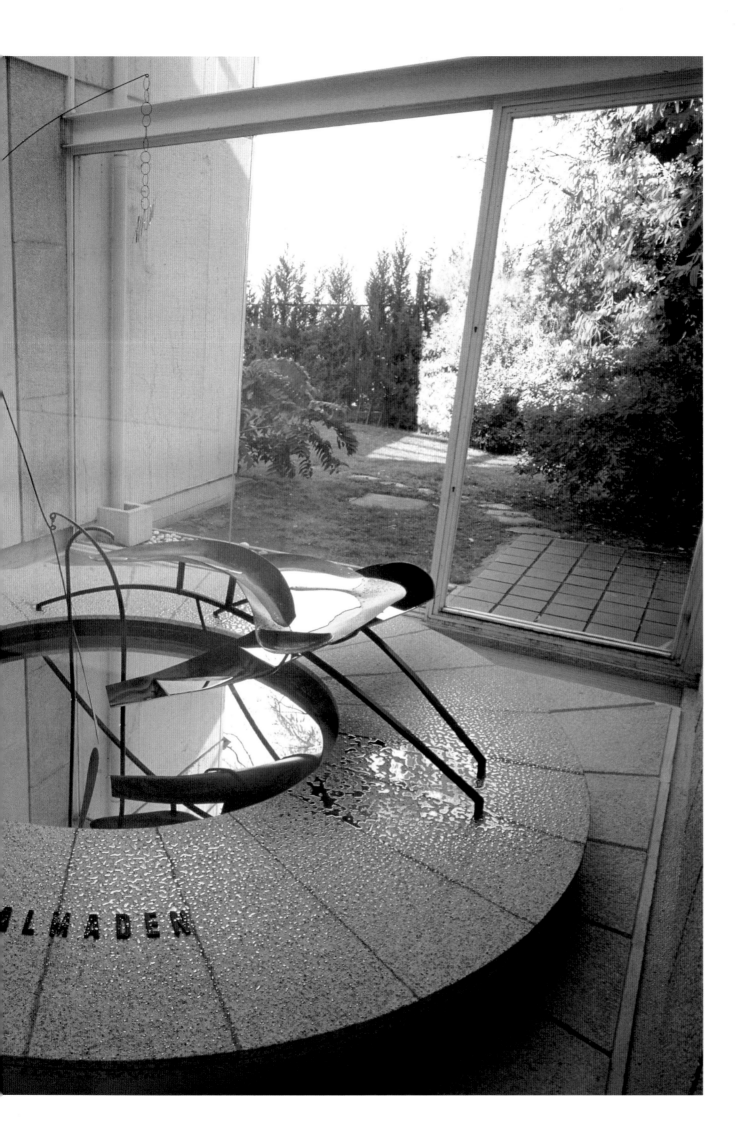

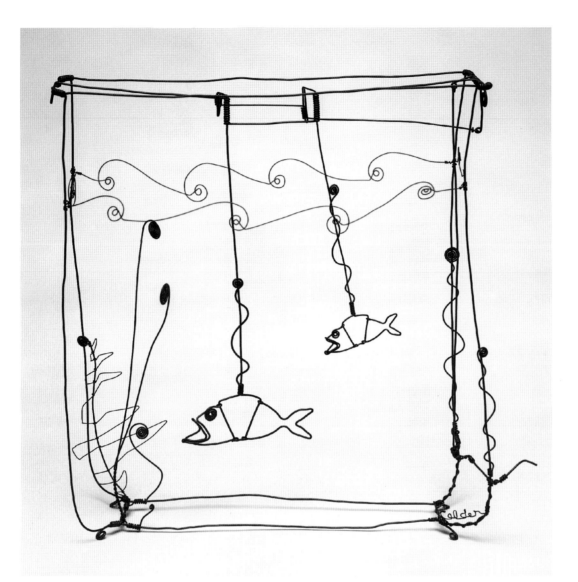

51 Goldfish Bowl, *1929*

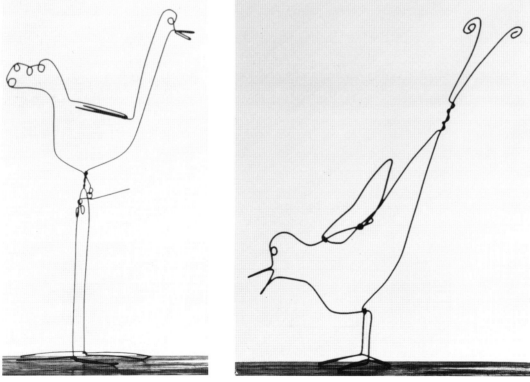

52 Male Bird, *1927*

53 Bird, *1927*

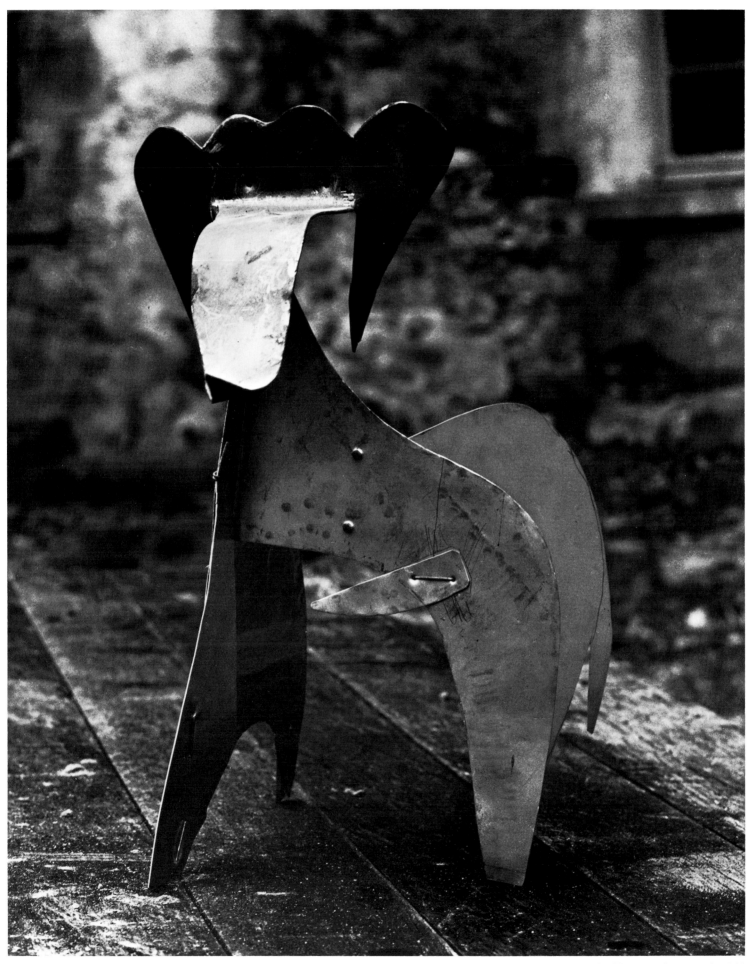

54 Elephant *(maquette), 1973*

Louisa's 43rd Birthday Present, *1948*

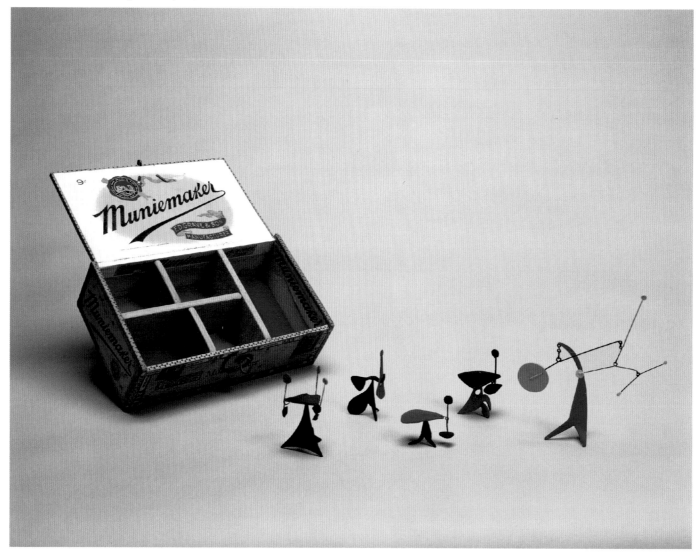

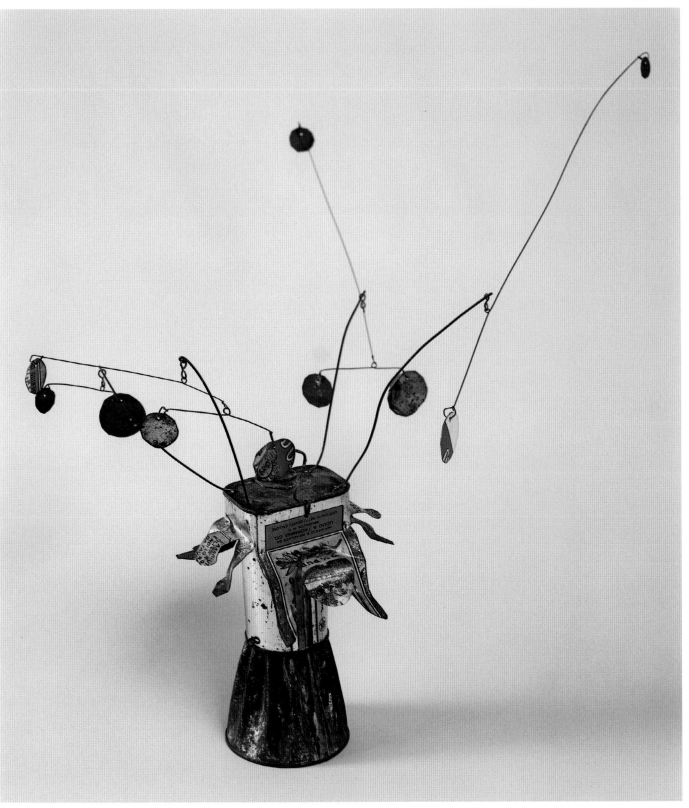

57 Horse II, *1944*

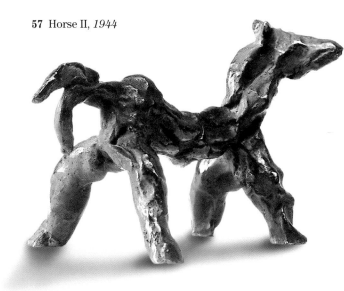

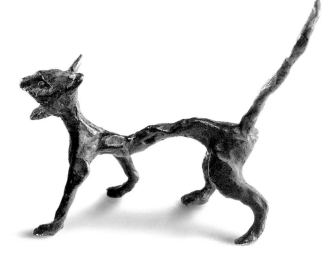

58 The Cat, *1944*

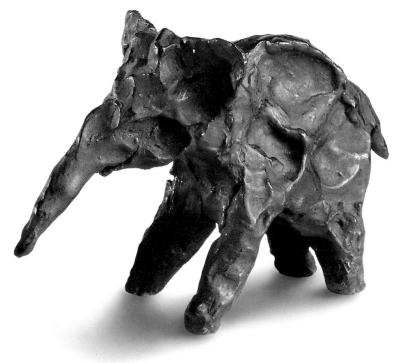

59 Éléphant, *1930*

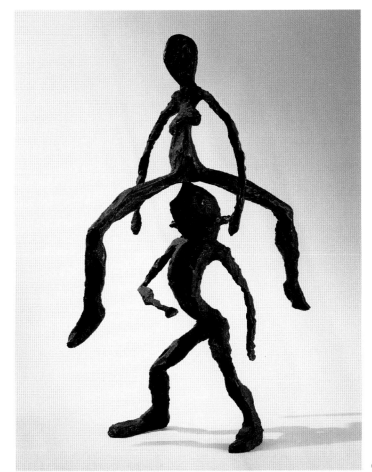

60 Acrobats II, *1944*

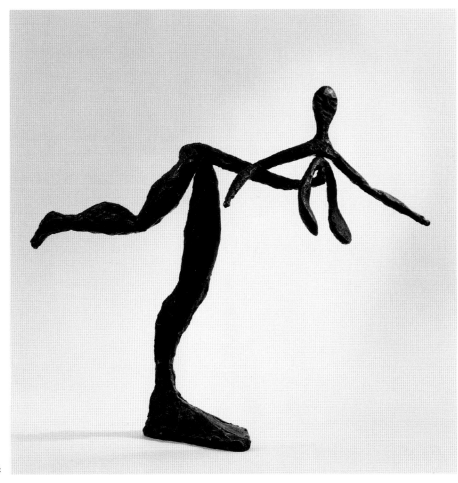

61 The Dancer (La danseuse), *1944*

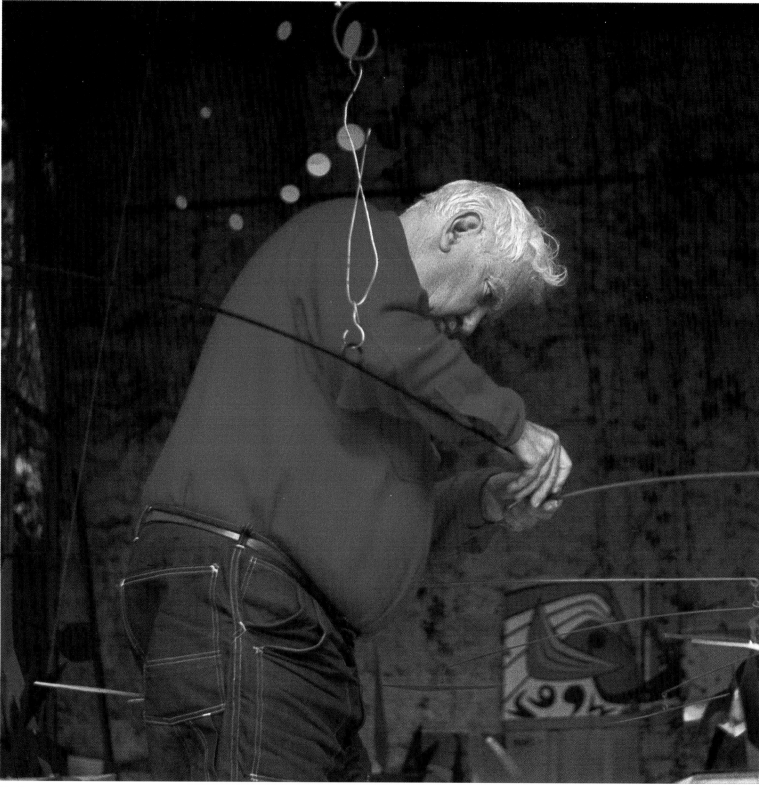

62 *Calder in his studio*

Opposite:
63 The Pagoda, *1963*

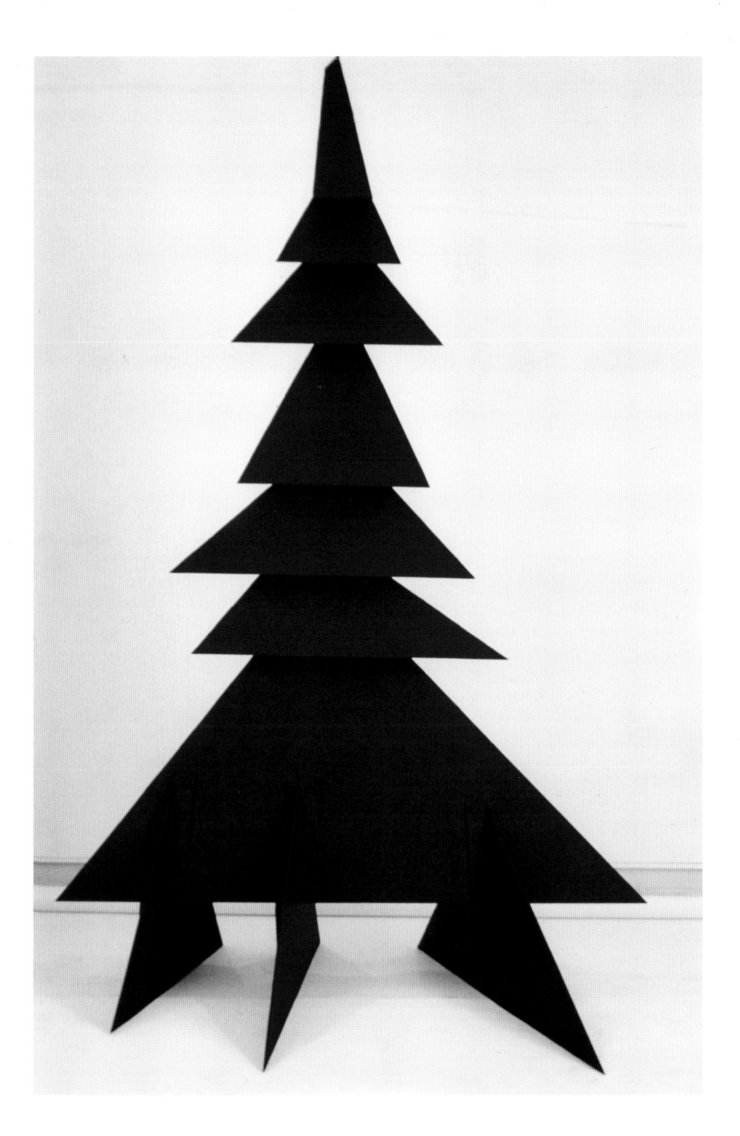

List of Plates

1 Caniche, *1932. Ink on paper, 22¾ × 30⅝" (58 × 78 cm). Private collection. Photo: Benjamin Krebs*

2 Cirque Calder, *1926–32. Mixed media, overall: 54 × 94¼ × 94¼" (137.2 × 239.2 × 239.2 cm), with accessories: 76½ × 97¾ × 96¾" (194.3 × 248.3 × 245.7 cm). Whitney Museum of American Art, New York. Purchased with funds from public fundraising campaign, May 1982. Contributions made by: Robert Wood Johnson Jr. Charitable Trust; The Lauder Foundation; the Robert Lehman Foundation, Inc.; the Howard and Jean Lipman Foundation, Inc.; the T. M. Evans Foundation, Inc.; MacAndrews & Forbes Group, Inc.; the Dewitt Wallace Fund, Inc.; Martina and Agneta Gruss; Anne Phillips; Mr. and Mrs. Laurance S. Rockefeller; the Simon Foundation, Inc.; Marylou Whitney; Bankers Trust Company; Mr. and Mrs. Kenneth N. Dayton; Joel and Anne Ehrenkranz; Irvin and Kenneth Feld; Flora Whitney Miller; and anonymous donor. Photo: Jerry. L. Thompson*

3–8 *Circus drawings, 1926–32*

3 Dame de pegase. *Ink on paper, 11 × 8⅝" (28 × 22 cm). Collection Galerie Maeght, Paris*

4 Cowboy. *Ink on paper, 11 × 8⅝" (28 × 22 cm). Collection Galerie Maeght, Paris*

5 Dompteur de l'éléphant. *Ink on paper, 11 × 8⅝" (28 × 22 cm). Collection Galerie Maeght, Paris*

6 Chef de piste. *Ink on paper, 11 × 8⅝" (28 × 22 cm). Collection Galerie Maeght, Paris*

7 Dompteur du lion. *Ink on paper, 11 × 8⅝" (28 × 22 cm). Collection Galerie Maeght, Paris*

8 Taureau. *Ink on paper, 11 × 8⅝" (28 × 22 cm). Collection Galerie Maeght, Paris*

9 Josephine Baker, *1928. Wire, 39¾ × 37⅜ × 9⅞" (101 × 95 × 25 cm). Musée national d'art moderne, Centre Georges Pompidou, Paris*

10 *Untitled, c. 1936. Assemblage of ebony and painted wood, 36¼ × 9 × 3⅞" (92 × 22.8 × 10 cm). Institut Valencia d'Art Modern, Centro Julio Gonzalez, Valencia, Spain. Photo: Juan Garcia Rosell*

11 Petit panneau bleu/Little Blue Panel, *c. 1938. Painted wood, sheet metal, steel, wire, and motor, 14 × 19⅜ × 16⅞" (35.5 × 49.1 × 43 cm). Musée national d'art moderne, Centre Georges Pompidou, Paris*

12 *Untitled (Day and Night), c. 1937. Painted wood and wire, 8½ × 9½ × 7⅞" (21.5 × 24 × 20 cm). Collection Galerie Maeght, Paris*

13 Yellow Panel, *c. 1940–41. Wood, painted metal, steel rods, motor, 70 × 39 × 15¾" (178 × 99 × 40 cm). Musée national d'art moderne, Centre Georges Pompidou, Paris*

14 Constellation with Sundial, *c. 1943. Painted wood, wire, 23 × 28½ × 15¾" (58.5 × 72.5 × 40 cm). Musée national d'art moderne, Centre Georges Pompidou, Paris. Photo: Philippe Migeat*

15 Mobile (Pantograph), *1931. Painted wood, metal, wire, and motor, 35½ × 44½ × 22" (90 × 113 × 56 cm). Moderna Museet, Stockholm*

16 *Untitled, c. 1931. Wood, painted metal, wire, 47¼ × 29⅛ × 11⅞" (120 × 74 × 30 cm). Collection Museu d'Art Contemporani de Barcelona, Provenant de Fundacio Museum d'Art Contemporani*

17 *Lionne, 1929. Wood, 15¾ × 31½" (40 × 80 cm). Private collection*

18 *Mobile sur deux plans, c. 1955. Painted sheet aluminum and steel wire, 78¾ × 47¼ × 43¼" (200 × 120 × 110 cm). Musée national d'art moderne, Centres Georges Pompidou, Paris*

19 Dancing Stars, *c. 1945. Painted metal, 23⅝ × 35⅜" (60 × 90 cm). Nationalgalerie, Berlin. Photo: Bildarchiv, Berlin*

20 Red, White, Blue, and Black, *1948. Painted metal, 72 × 90½" (183 × 230 cm). Private collection. Photo: Benjamin Krebs*

21 Bird on the Tree Branch, *1949. Painted sheets of metal, sticks, and wire, 77½ × 78¾" (197 × 200 cm). Moderna Museet, Stockholm*

22 Trois soleils jaunes, *1965. Painted metal, 47¼ × 94½" (120 × 240 cm). Fondation Maeght, Saint-Paul-de-Vence*

23 Four Discs Red Counterweight, *1975. Painted metal, 24⅝ × 49⅝" (62.5 × 129.04 cm). Private collection, New York. Photo: ESM/Art Resource, New York*

24 Sumac V, *1953. Painted sheets of metal and wire, 49¼ × 55⅛" (125 × 140 cm). Collection Galerie Maeght, Paris*

25 Antennae with Red and Blue Dots, *c. 1953. 43¾ × 50½" (111 × 128.2 cm). Tate Gallery, London. Photo: Art Resource, New York*

26 Spider Web, *1965. Painted metal, 118⅛ × 236" (300 × 600 cm). Collection Galerie Maeght, Paris*

27 *Untitled, 1970. Painted metal and metal rods, 37⅜ × 120" (94.6 × 304.8 cm). Musée de Grenoble*

28 Tom's, *1974. Painted steel, 24'7¼" × 18'½" × 21'11¾" (7.5 × 5.5 × 6.7 m). Private collection. Photo: ESM/Art Resource, New York*

29 Stabile, *1949. Oil on canvas, 27¾ × 24" (70.5 × 61 cm). Collection Galerie Maeght, Paris.*

30 Porc qui pique (maquette), *1964. Model, painted sheets of metal, 15¾ × 15¾ × 15¾" (40 × 40 × 40 cm). Collection Galerie Maeght, Paris*

31 Saurien, *1975. Steel plate, 19'8¼" × 19'8¼" × 19'8¼" (6 × 6 × 6 m). Photo: ESM/Art Resource, New York*

32 Angulaire, *1975. Steel plate, 11'5¾" × 9'10⅛" × 7'10½" (3.5 × 3 × 2.4 m). Photo: ESM/Art Resource, New York*

33 Object in Five Planes/Peace *(maquette), 1965. Painted steel, 8 x 7½ x 7½" (20.3 x 19 x 19 cm). Photo: ESM/Art Resource, New York*

34 Peau Rouge *(intermediate maquette), 1969. Painted steel, 91¾ x 90½ x 76¾" (233 x 230 x 195 cm). Photo: ESM/Art Resource, New York*

35 Four Wings, *1972. Painted steel, 196⅞ x 139⅜ x 126" (500 x 354 x 320 cm). Fundació Miró, Barcelona. Donated by Alexander Calder*

36 Flamingo, *1973. Painted steel, 53 x 60 x 24' (16.15 x 18.54 x 7.31 m). Federal Center Plaza, Chicago. Photo: Keith Collie*

37 Les renforts *(maquette), c. 1962. 22⅞ x 16⅞ x 14⅛" (58 x 43 x 36 cm). Collection Galerie Maeght, Paris*

38 Trois bollards *(maquette), 1969. 27½ x 25¼ x 25¼" (70 x 64 x 64 cm). Collection Galerie Maeght, Paris*

39 Gothic Construction from Scraps, *1939. Sheet metal, 28½ x 25⅝ x 12⅝" (72.5 x 65 x 32 cm)*

40 Two Moons, *1969. Painted steel, 32½ x 36 x 37" (82.5 x 91.4 x 93.9 cm). Norton Simon Museum, Pasadena, California. Photo: ESM/Art Resource, New York*

41 Five Empties/Three Up Three Down, *c. 1973. Painted steel, 25'5" x 20'10" x 20'10" (7.74 x 6.35 x 6.35 m). Photo: ESM/Art Resource, New York*

42 Carmen, *1974. 25 x 38' (7.62 x 11.58 m). Photo: ESM/Art Resource, New York*

43 Small Crinkly, *1976. 141¾ x 155½" (360 x 395 cm). Calder Retrospective, 1984. Palazzo a Vela, Turin. Photo: Paluan/Art Resource, New York*

44 Lily of Force, *1945. Painted sheet metal and iron wire, 72 x 90½" (183 x 230 cm). Private collection, France. Photo: Paluan/Art Resource, New York*

45 Sorel Horse, *1975. Knoedler Gallery, New York. Photo: Paluan/Art Resource, New York*

46 Horizontal Yellow, *1972. Painted metal, 30 x 27 x 16⅞" (76.2 x 68.5 x 43.1 cm). Photo: ESM/Art Resource, New York*

47 Under the Table, *1952. Painted metal and wire, 51⅛ x 29½ x ¾" (130 x 75 x 2 cm). Musée d'Art moderne de la ville de Paris*

48 Calder in his studio, Saché, August 1967. Photo: AKG *Paris/Tony Vaccaro*

49 Reims croix du sud, *1969. 23' x 19'6" x 29'6" (7 x 6 x 9 m)*

50 Mercury Fountain, *1937, for the Spanish Pavilion of the Paris Exposition. Painted metal, glass, polished steel, pitch, and mercury, 44⅞ x 115⅜ x 77⅛" (114 x 293 x 196 cm). Fundació Miró, Barcelona*

51 Goldfish Bowl, *1929. Wire, 16 x 15 x 5⅞" (40.5 x 38 x 15 cm). Private collection*

52 Male Bird, *1927. Wire, 14 x 4 x 7⅞" (35.6 x 10.2 x 20 cm). Private collection*

53 Bird, *1927. Wire, 12¾ x 9⅞ x 4⅛" (32.4 x 25.1 x 10.5 cm). Private collection*

54 Elephant *(maquette), 1973. 21½ x 19½ x 15" (54.6 x 49.5 x 38.1 cm). Private collection*

55 Louisa's 43rd Birthday Present, *1948. Cigar box, felt, and brass. Five mobiles of painted metal, 2⅝ x 8⅝ x 4⅞" (6.5 x 22 x 12.5 cm). Private collection*

56 Birthday Cake (Candleholder), *c. 1955. Metal, 56 x 44 x 38" (142.2 x 111.7 x 96.5 cm). Private collection*

57 Horse II, *1944. Bronze, height: 4¾" (12 cm). Fondation Maeght, Saint-Paul-de-Vence*

58 The Cat, *1944. Bronze, height: 5⅛" (13 cm). Fondation Maeght, Saint-Paul-de-Vence*

59 Éléphant, *1930. Bronze, height: 5¾" (14.5 cm). Fondation Maeght, Saint-Paul-de-Vence*

60 Acrobats II, *1944. Bronze, 20¼ x 13⅜ x 9½" (51.5 x 34 x 24 cm). Fondation Maeght, Saint-Paul-de-Vence*

61 The Dancer (La danseuse), *1944. Height: 27" (68.5 cm). Fondation Maeght, Saint-Paul-de- Vence*

62 *Calder in his studio*

63 The Pagoda, *1963. Painted steel, 121 x 78 x 62" (307.3 x 198.1 x 157.5 cm). Photo: ESM/Art Resource, New York*

Selected Bibliography

Bruzeau, Maurice. *Calder*. Translated by I. Mark Paris. New York: Harry N. Abrams, 1979.

Calder, Alexander. *An Autobiography with Pictures*. With an introduction by Robert Osborn. New York: Pantheon, 1966.

Calder. Catalogue of the Musée d'Art Moderne de la Ville de Paris, 1996.

Gibson, Michael. *Calder*. Paris: Éditions Hazan, 1988.

Marcadé, Jean-Claude. *Calder*. Paris: Flammarion, 1996.

Marchesseau, Daniel. *The Intimate World of Calder*. Translated by Eleanor Levieux and Barbara Shuey. Paris: Solange Thierry Éditeur, 1989; distributed in U.S. by Harry N. Abrams. Originally published as *Calder intime*.

Marter, Joan. *Alexander Calder*. New York: Cambridge University Press, 1991.

Pierre, Arnauld. *Calder, La sculpture en mouvement*. Paris: Découvertes-Gallimard/Paris-Musées, 1996.

Sweeney, James Johnson. *Alexander Calder*. New York: Museum of Modern Art, 1951.

"Voyages," *Calder*. Maeght, 1992.

Series Coordinator, English-language edition: Ellen Rosefsky Cohen
Editor, English-language edition: Julia Gaviria
Designer, English-language edition: Judith Michael

Library of Congress Catalog Card Number: 97–77346
ISBN 0–8109–4668–8

Published in 1998 by Harry N. Abrams, Incorporated, New York

Printed and bound in Spain by Filabo, S.A.

Dep. Leg.: B. 38.128–1997